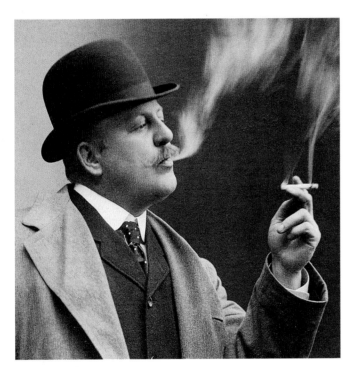

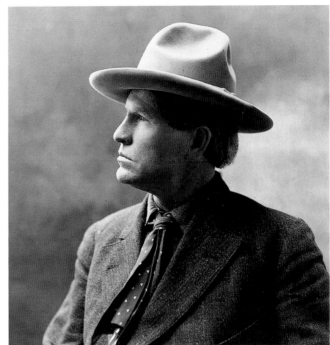

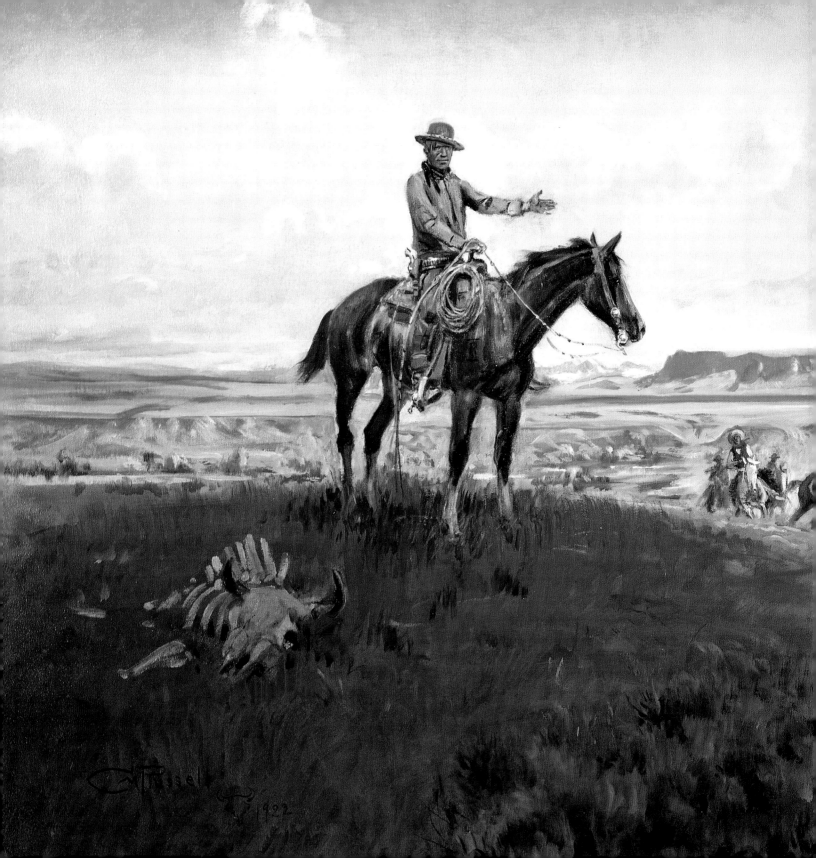

Remington, Russell

AND THE LANGUAGE OF WESTERN ART

PETER H. HASSRICK

TRUST FOR MUSEUM EXHIBITIONS · WASHINGTON, D.C.

Published in 2000 by the
Trust for Museum Exhibitions
1424 16th Street, N.W., Suite 600
Washington, D.C. 20036

ISBN: 1-882507-10-X

Prepared for publication by
Archetype Press, Inc., Washington, D.C.
Diane Maddex, Project Director
Gretchen Smith Mui, Editor
Robert L. Wiser, Designer

Printed in Hong Kong

10 9 8 7 6 5 4 3 2 1

Page 1: Photographs of Frederic Remington, ca. 1902 (figure 4), and Charles M. Russell, 1907 (figure 5) (details). Pages 2–3: Charles M. Russell, *Charles M. Russell and His Friends*, 1922 (figure 58) (detail). Pages 4–5: Charles M. Russell, *The Stand. Crossing the Missouri*, ca. 1889 (figure 43) (detail). Pages 6–7: Frederic Remington, *Radisson and Groseilliers*, 1905 (figure 40) (detail). Pages 12–13: Charles M. Russell, *Capturing the Grizzly*, 1901 (figure 93) (detail). Pages 20–21: Frederic Remington, *The Advance*, 1896–98 (figure 112) (detail). Pages 42–43: Frederic Remington, *The Smoke Signal*, 1905 (figure 78) (detail). Pages 124–25: Charles M. Russell, *The Slick Ear*, 1914 (figure 94) (detail). Pages 158–59: Charles M. Russell, *Mexican Buffalo Hunters*, 1924 (figure 101) (detail). Page 166: Frederic Remington, *The Cheyenne Scout*, 1890 (figure 76) (detail). Page 176: Photographs of Frederic Remington, 1883 (figure 19), and Charles M. Russell, ca. 1884 (figure 16) (details).

All images shown in detail also appear in their entirety elsewhere in the catalogue.

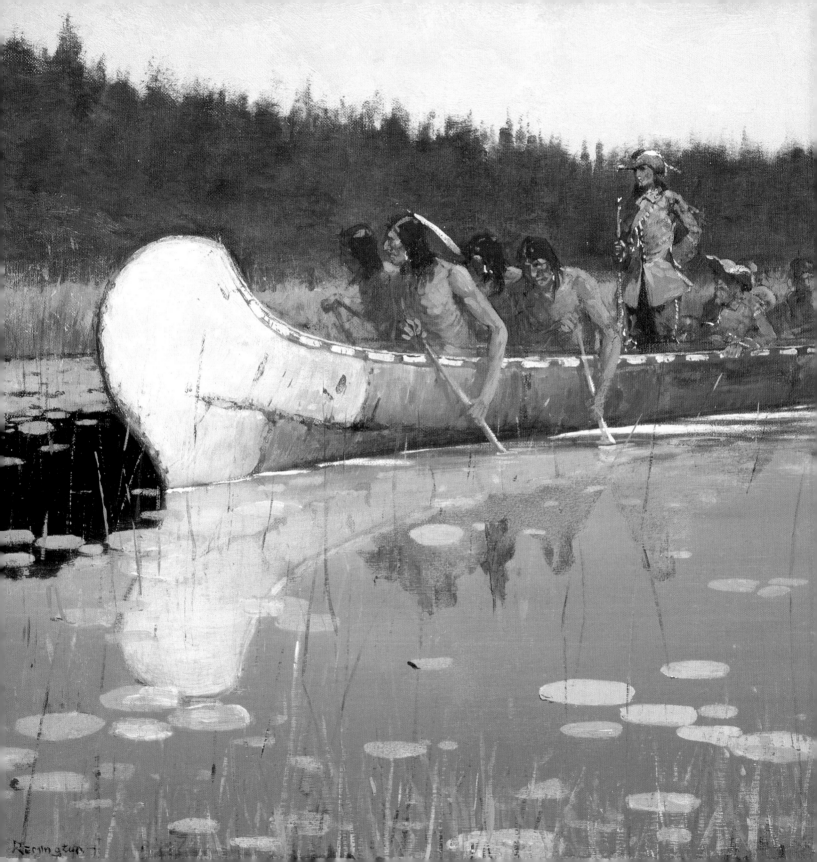

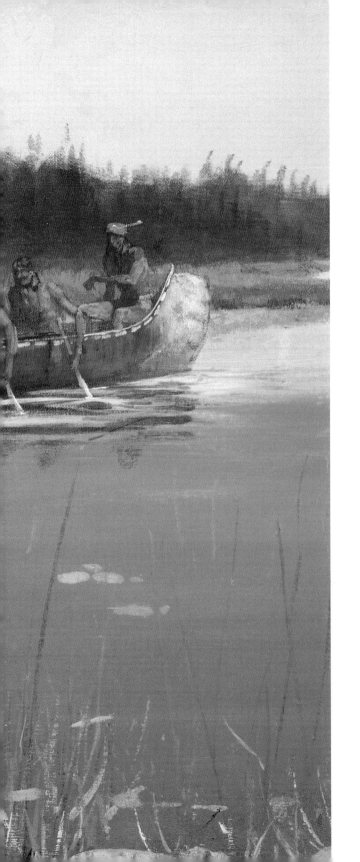

Contents

THIS CATALOGUE IS MADE POSSIBLE
THROUGH THE GENEROSITY OF MRS. PATRICK HEALY III.

Acknowledgments

In the summer of 1998 I approached Peter Hassrick, director of the Charles M. Russell Center for the Study of Art of the American West, University of Oklahoma, with the suggestion of developing an exhibition devoted to the two best-known American western artists: Frederic Remington and Charles M. Russell. My suggestion was met with enthusiasm.

Such an exhibition is long overdue, and it is only appropriate that the leading scholar on the subject—anywhere—be guest curator. Peter has given us a superb show and an excellent catalogue, and we are deeply in his debt for his outstanding productions.

Yet what would we have without our sixty-five lenders? Without their generous contributions, a good idea would have remained just that. I extend my deepest thanks to each and every one. For exceptional contributions, Peter joins me in giving special recognition to David Bolger and Mark Costello, Thomas Petrie, Ginger Renner, and Mr. and Mrs. William D. Weiss, as well as the Amon Carter Museum (Rick Stewart), Buffalo Bill Historical Center (Byron Price and Sarah Boehme), Frederic Remington Art Museum (Lowell McAllister and Laura Foster), Gilcrease Museum (Brooks Joyner and Ann Morand), and The Rockwell Museum of Western Art (Stewart Chase).

Of course, even with loans secured, a scholarly and entertaining catalogue was essential. Peter has produced a volume that recounts the story of the limelight that Remington and Russell shared, the interplay involved, and the stories of rivalry swirling about them. Again I join our guest curator in acknowledging the special help with this catalogue provided by the Art Museum of South Texas (William G. Otton, director); *Annals of Wyoming*; Stephanie Foster Rahill, Tracy Shaw, and James C. Moore.

I also extend my appreciation to the five museums that are hosting *Remington, Russell and the Language of Western Art* and to Archetype Press for preparing the catalogue for publication. And no work emanating from the Trust for Museum Exhibitions would be possible without TME's talented and dedicated staff. Special credit is due to the brilliant input of Diane Salisbury, director of exhibitions; Katalin Banlaki, exhibitions officer; and Jerry Saltzman, volunteer. A resounding thank you to all.

Ann Van Devanter Townsend
President
Trust for Museum Exhibitions

Itinerary

November 19, 2000 – January 28, 2001
MEMPHIS BROOKS MUSEUM OF ART
Memphis, Tennessee

February 16 – April 8, 2001
THE SOCIETY OF THE FOUR ARTS
Palm Beach, Florida

April 26 – June 24, 2001
PORTLAND ART MUSEUM
Portland, Oregon

July 7 – September 16, 2001
BOWERS MUSEUM OF CULTURAL ART
Santa Ana, California

October 5 – December 9, 2001
FRED JONES JR. MUSEUM OF ART
Norman, Oklahoma

Lenders
to the Exhibition

Amon Carter Museum, Fort Worth, Texas

The Art Institute of Chicago
Chicago, Illinois

The Art Museum, Princeton University
Princeton, New Jersey

Autry Museum of Western Heritage
Los Angeles, California

Birmingham Museum
Birmingham, Alabama

David P. Bolger and Mark A. Costello
Chicago, Illinois

Wiley T. Buchanan III, Washington, D.C.

Buffalo Bill Historical Center
Cody, Wyoming

California State Parks—Will Rogers State
Historic Park, Pacific Palisades, California

Carnegie Museum of Art
Pittsburgh, Pennsylvania

The C. M. Russell Museum
Great Falls, Montana

Charles M. Russell Center, University
of Oklahoma, Norman, Oklahoma

Jim Combs, Great Falls, Montana

The Cornish Colony Gallery
and Museum, Cornish, New Hampshire

Joe Crosby, Oklahoma City, Oklahoma

Desert Caballeros Western Museum,
Wickenburg, Arizona

Diplomatic Reception Rooms
U.S. Department of State, Washington, D.C.

Fenimore Art Museum
Cooperstown, New York

The Flint Institute of Arts, Flint, Michigan

Frederic Remington Art Museum
Ogdensburg, New York

Genesee Country Village and Museum
Mumford, New York

Gilcrease Museum, Tulsa, Oklahoma

Glenbow Museum
Calgary, Alberta, Canada

The Gund Collection of Western Art
Indianapolis, Indiana

Harry Ransom Humanities Research
Center, The University of Texas
at Austin, Austin, Texas

Peter H. Hassrick, Norman, Oklahoma

Mr. and Mrs. William P. Healey
Santa Barbara, California

Hood Museum of Art, Dartmouth
College, Hanover, New Hampshire

Houston Museum of Natural Science
Houston, Texas

The Hubbard Museum of the American
West, Ruidoso Downs, New Mexico

Indianapolis Museum of Art
Indianapolis, Indiana

Jack S. Blanton Museum of Art
The University of Texas at Austin
Austin, Texas

Lawrence Klepetko, Denver, Colorado

Library of Congress, Washington, D.C.

MSC Forsyth Center Galleries, Texas
A&M University, College Station, Texas

James W. and Fran McGlothlin

Memphis Public Library
Memphis, Tennessee

Christopher John Minnick
Livermore, California

Missouri Historical Society
St. Louis, Missouri

Montana Historical Society
Helena, Montana

Museum of Fine Arts, Boston
Boston, Massachusetts

National Cowboy Hall of Fame
and Western Heritage Center
Oklahoma City, Oklahoma

National Museum of Wildlife Art
Jackson Hole, Wyoming

Dr. and Mrs. Van Kirke Nelson
Kalispell, Montana

The Nelson-Atkins Museum of Art
Kansas City, Missouri

New York Public Library
New York, New York

Nita Stewart Haley Memorial Library
Midland, Texas

Owen D. Young Library, Canton, New York

Thomas Petrie, Denver, Colorado

Arthur J. Phelan, Chevy Chase, Maryland

The Philbrook Museum of Art
Tulsa, Oklahoma

Phoenix Art Museum, Phoenix, Arizona

Frederic G. and Ginger K. Renner
Collection, Paradise Valley, Arizona

Michael and Katherine Renner
Rockville, Maryland

The Richard and Jane Manoogian
Foundation, Taylor, Michigan

The Rockwell Museum of Western Art
Corning, New York

Tom Ryan, Midland, Texas

The Saint Louis Art Museum
St. Louis, Missouri

Santa Barbara Museum of Art
Santa Barbara, California

Spencer Museum of Art, The University
of Kansas, Lawrence, Kansas

Taylor Museum, Colorado Springs Fine
Arts Center, Colorado Springs, Colorado

The University of Arizona Museum
of Art, Tucson, Arizona

University of Oklahoma Libraries
Norman, Oklahoma

Mr. and Mrs. W. D. Weiss
Jackson, Wyoming

"The Most Celebrated Artists of the West"

New York City was the last place on earth that Charles M. Russell (1864–1926) wanted to be in the winter of 1904. For many from America's hinterlands a visit there might have represented welcome stimulation, an invigorating cultural lift, but for this middle-aged Montanan, this gentle iconoclast of the northwestern prairies, it was an uncomfortable and rather alienating experience. He did not fit this city of excess and indifference; in fact, it symbolized a great many things that to him were fundamentally distasteful. "New York is all right," Russell reported to his hometown newspaper when he returned to Great Falls, Montana, in mid-February that year, "but not for me. It's too big and there are too many tall teepees." He anguished over the breadlines he had passed. They were "a tough sight," and the fact that "you've got to be a millionaire to be anybody" rankled his western egalitarian senses.[1]

Rather than marveling, Russell disdained the dizzying height of its buildings as they spired skyward, resembling marbled fortresses of mammon. He shuddered at the dark, congested streets, at the squalor and poverty that would take the whole Progressive Era to even begin to clean up. He could not understand the city's pace, did not know how to synchronize with its rhythms, and had little use for the

Russell's oil painting *Capturing the Grizzly* (figure 93) was exhibited at the 1904 world's fair in St. Louis, where a monumental plaster model of Remington's bronze *Coming Thru the Rye* (figure 12) ornamented one entrance.

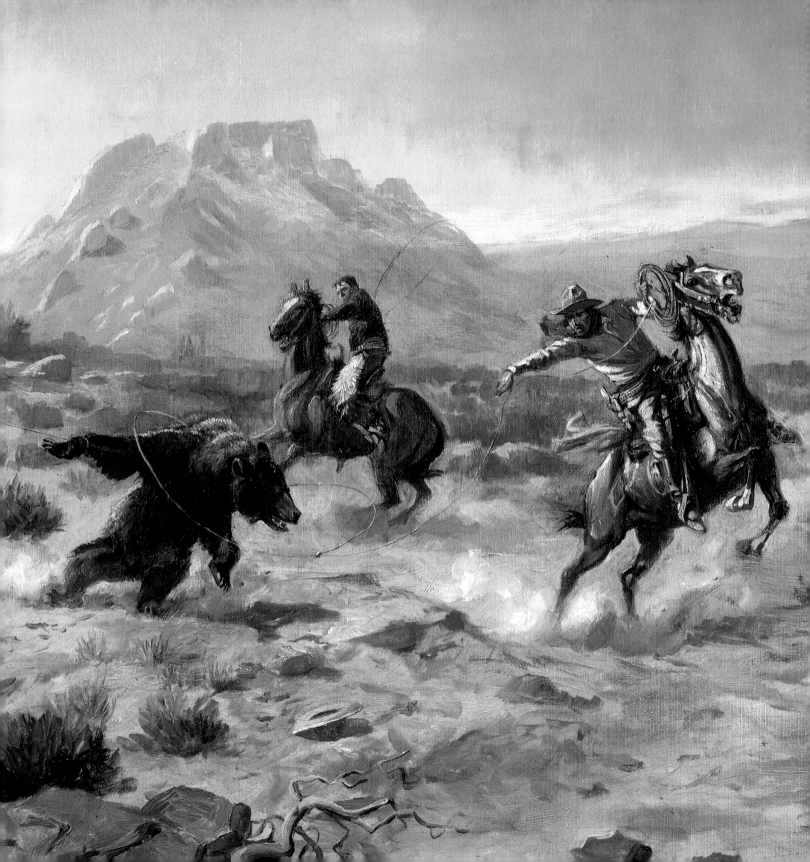

crowded masses—he called them "cliff dwellers"—whose homes terraced one above another into the sky.[2] Certainly, once back in Great Falls, he was glad to be home, and he let his admiring town know it. "My advice, to anybody that does not love home, is to just go down and live in New York for a while. He'll sure love home then."[3]

Russell, accompanied by his wife, Nancy, had gone to New York at the invitation of a group of illustrators who worked and lived there. They were most solicitous of their country cousin, charmed as they were by his good-natured innocence and inspired by his innate talent and first-hand experience in the West. One among their ranks, John Marchand (1875–1921), was especially interested in cowboy subjects and had even ventured to Montana the year before to collect material. He had met Russell then and boasted to the *Great Falls (Mont.) Daily Tribune* that there was not "any one who can 'touch' him on his subjects."[4] Marchand was now living up to a promise he had made to introduce his Montana colleague to publishers and writers in the city. "I met a lot of artists and illustrators," Russell remarked later. "They are a mighty fine lot of fellows and they treated me out of sight."[5]

There was one important New York artist whom Russell did not meet at that time, however: Frederic Remington (1861–1909). Urbane and poised, he lived north of the city in New Rochelle but conducted most of his business as an artist in Manhattan and moved quite comfortably with its bustling cadence. Marchand, who knew Remington and the New York art scene well, had admitted in his interview with the *Great Falls Daily Tribune* that he and his troop of illustrators were no match for Russell, by implication including Remington as well. It was a sweeping approbation, one meant predominantly to bolster local pride in Montana and not for broader national scrutiny or consideration. For more than a decade Remington had enjoyed the reputation, although not entirely unassailable, as the East's singular artistic champion of subjects related to the West. "It is a fact that admits of no question," the art critic William A. Coffin had written in 1892, "that Eastern people have formed their conceptions of what the Far-Western life is like more from what they have seen in Mr. Remington's pictures than from any other source...."[6]

In 1904 Remington was still fairly secure in this place of honor, even though he had recently lost ground in some quarters. A New Jersey competitor, Charles Schreyvogel (1861–1912), gained ascendancy after a nasty press fight with Remington in the *New York Herald* over the

1. Photographer unknown, *Charles Russell Painting in His Studio*, 1910. Photograph, 6 3/4 × 8 inches. Taylor Museum, Colorado Springs Fine Arts Center, Colorado Springs, Colo. Britzman Collection.

accuracy of costume detail in one of Schreyvogel's paintings entitled *Custer's Demand*.[7] As a result, some in the New York press had anointed Schreyvogel the leading painter of the western frontier.[8] Moreover, a year earlier Lorado Taft (1860–1936), a sculptor and student of American art, had published *The History of American Sculpture*, in which he had slighted Remington by exclusion, proclaiming the Utah-born artist Solon Borglum (1868–1922) as the true "original"

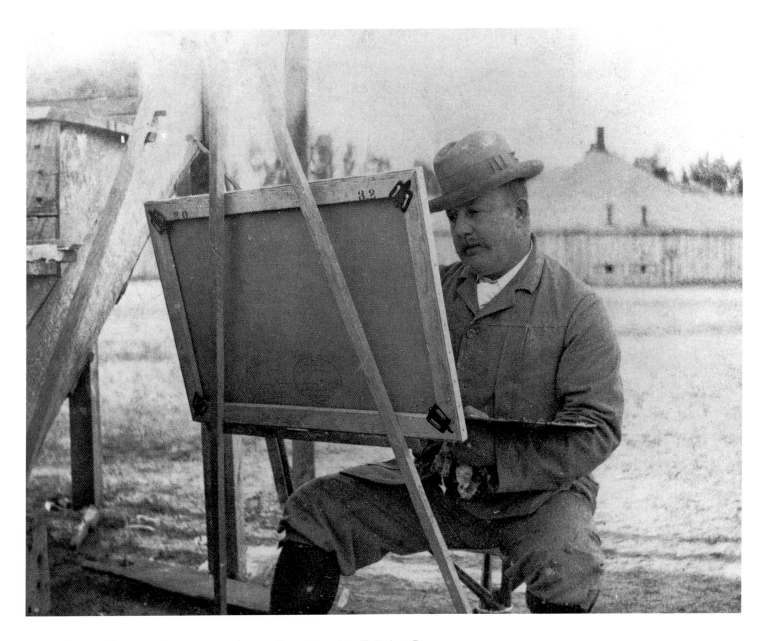

in the production of western sculpture. It mattered to Taft that Borglum was a "genuine product of the West," concluding that the nation could "feel real gratitude" for his "new contributions to American art, contributions as novel and personal as they are powerful."[9] As Taft well knew, Remington had been creating bronzes with western themes for nearly a decade, beginning with his triumphant 1895 statuette *The Broncho Buster* (figure 8).

2. Photographer unknown,
Frederic Remington Painting at Fort Robinson,
1905. Photograph, 3 × 5 inches.
Frederic Remington Art Museum,
Ogdensburg, N.Y.

But Borglum was not wholly a product of the West; he had a studio in New York at that time and was fresh from the ateliers of Paris. What was potentially more threatening to Remington's station was an assault from the West itself by a person who, in his presentation of western themes through art, could persuade western as well as eastern audiences of their aesthetic merit and material veracity. That person was Charles Russell, a self-effacing, demurely provincial small-town humorist and raconteur whose bowed legs and high-heeled boots could hardly carry him up Fifth Avenue. Nonetheless, his paintings and bronzes captured the public fancy and positioned him to share the national limelight with Remington into the next one hundred years and beyond.

This volume recounts the story of that shared limelight, its interplay and tensions. Who were Remington and Russell, how did their art interact, and why and how were they lionized by generations? Most important, despite their fundamental differences, why are they so inextricably joined in the public mind as the paragons of western art? For students and aficionados of western American art, the greatest temptation—and the one most frequently succumbed to—is the desire to compare the life and talents of these two titans. Almost everyone who treats the subject of western art in broad terms inevitably pairs these two names. And when the two occur in the same sentence and are followed, as invariably they are, by a description such as "the most celebrated artists of the West," offered by the historian Robert Taft in 1953, then author and reader are often teased into making comparative judgments on the relative merits of the two.[10]

It is a game that has been played as long as there have been artists and as long as there have been patrons, audiences, and critics. For Remington and Russell, the split did not begin in earnest until February 1904, when the latter first set foot on Remington's home turf of New York. They are thought to have met later, in November 1904, when Charles and Nancy Russell visited New York for a second time, but the two artists apparently never communicated further, and the contest between them was essentially fought out in the press without either of the artists really participating, at least directly. Although camps of followers developed, neither Remington nor Russell fanned the flames between 1903 and Remington's premature death in 1909. By then the lines were well drawn, and, although writers have

March 2º 1918

Dear Brother Van

I received an invation to your birthday party
from Reverend Bunch
and am more than sorry that I cant be their
but I'm on the jury
I think it was about this time of year thirty
seven years ago that we first met at Babcocks
ranch in Pig eye bason on the upper Judith
I was living at that time with a hunter and trapper
Jake Hoover who you will remember He and I had
come down from the south fork with three pack
horses loaded with deer and elk meet which he
sold to the ranchers and we had stopped for
the night with old Bab a man as rough as
the mountians he loved but who was all
hart from his belt up and friends are strangers
were welcom to shove there feet under his table
this all welcom way of his made the camp a
hangout for many homeless mountian and
prairie men and his log walls and dirt roof
semed like a palice to those who lived mostly
under the sky
the evening you came there was a mixture
of bull whackers hunters and prospectors

who welcomed you with with hand shaks and
rough but friendly greetings
I was the only stranger to you so after Bob
interduced Kid Russell he took me to one side
and whispered
boy says he I dont savvy many samsingers
but Brother Van deals square
and when we all sat down to our elk meet beens
coffee and dryed apples under the rays of a
bacon grease light. these men who knew little
of law and one among them I knew wore
notches on his gun men who had not prayed
since they nelt at their mothers knee
bowd there heads while you Brother Van
gave thanks and when you finished some
one said A Men I am not shure but I
think it was a man who I heard later
was we had been a rode agent
I was sixteen years old then Brother Van
but have never forgotten your stay at Old Bobs
with men who's talk was generly emphasized
with fancy profanity but while you were
with us altho they had to talk slow and carful
there were never a slip. The out law at Bobs
was a sinner an non of us thair were Saints
but our harts were clean at least while you gave
thanks when the bold up said A men
you brought to the minds of these hard and
homeles men the face of there Mothers and few
can be bad while she is near
I have met you many times sinc that Brother
Van some times in lonley places but you never
were lonsum are alone for a man with scared
hands and feet stood be side you and near
him there is no hate so all you met loved
you

be good and youl be happy is an old saying
which many conterdict and say that goodniss
is a rough trail over dangerous passes with
wind falls and swift deep rivers to cross
I have never ridden it verry far my self
but judging from the looks of you its a sinde
bet that with a hoss called faith under you
its a smooth flower growe trail with easy fords
where birds sing and cold clear streams dance
in the sun light all the way to the pass that
crosses the big devide
Brother Van you have ridden that trail a long
time and I hope you still ride its many
birth days on this side of the big range
with best wishes from my
best half and me
your Friend CM Russell

amplified and expanded the arguments since, the fundamental basis for celebrating one artist over the other has changed little.

Such battles often sap or at least seriously divert the energies of the artists involved, as was the case with George Catlin (1796–1872) and his competitor John Mix Stanley (1814–72) in the early 1850s and with Albert Bierstadt (1830–1902) and Thomas Moran (1837–1926) a generation later. Each of these contests involved potential congressional patronage and no end of political maneuvering, posturing, and pandering to win government support.[11] For example, to gain official approval Stanley used an 1852 letter from Seth Eastman (1808–75), an artist who worked for the federal government, that provides a typical commentary of artist set against artist in the pursuit of enhanced stature and expanded patronage: "Having been requested by you to express my opinion as to the comparative merits of yours and Mr. Catlin's paintings of the Indians of this country, it affords me pleasure to say that I consider the artistic merits of yours far superior to Mr. Catlin's; and they give a better idea of the Indian than any works in Mr. Catlin's collection."[12]

With such approbation Stanley won his battle. Similarly, Moran was victorious over Bierstadt. But with Remington and Russell, there was no winner per se, just two frustrated men. In the final analysis, the comparisons did little more than fluster Remington and embarrass Russell. The purpose of this volume and the exhibition is to explore basic issues in the comparison of Remington and Russell without passing judgment or endeavoring to sway opinion—that is, to provide an objective comparative analysis. The book is deliberately short on biography but presents some of the more interesting similarities and differences between the two artists, thereby providing a balanced understanding of the two men and their artistic contributions.[13]

3. Charles M. Russell, *Letter to Brother Van*, March 20, 1918.
Pen and ink and watercolor, each page 9 5/8 × 7 3/4 inches.
Dr. and Mrs. Van Kirke Nelson, Kalispell, Mont. Trails End Collection.

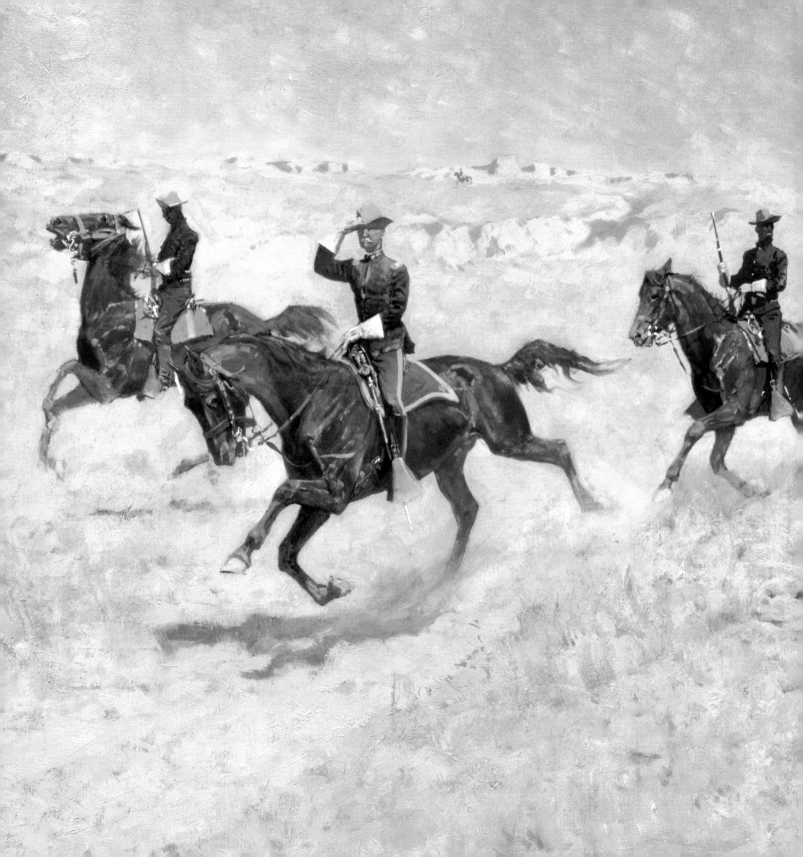

Frederic Remington

An Unwitting Rivalry

The year 1903 was critical for both Frederic Remington and Charles Russell. Change was imminent, and each was poised for a serious breakthrough in his career. In March of that year *Outing* magazine included a feature on Remington setting forth the observations of Edwin Wildman, a writer who had spent most of the previous summer as a neighbor of Frederic and Eva Remington's at their camp on the St. Lawrence River.[1] He had watched Remington at work and play and had fashioned a portrait of a man exuberant in spirit and open to change.

Wildman described Remington as a unique talent depicting western themes of "Indians, cowboys and bronchos ... as no one else ever has, or ever can."[2] A man of great presence, both physical and intellectual, Remington was blunt yet humorous. He exuded individuality, sparked with nervous energy, and overflowed with originality. Profoundly dedicated to his work, he also made time for recreation, particularly tennis and canoeing, which were equally important to him. He exercised hard, contending that "every man should get up a sweat once a day," and he worked creatively with equal diligence.[3] That summer, as Wildman watched from afar, Remington wrote his first novel, *John Ermine of the Yellowstone*, a sometimes humorous

In paintings such as *The Advance* (figure 112), Remington demonstrated a penchant for military subjects and the conquest of the West. Russell's popular cowboy subjects presented a similar, albeit less obvious, message.

but ultimately tragic account of East meets West, with woman representing the evils of civilization and human nature and man symbolizing a victimized, vanishing frontier and its native people. The book was intended to counter (some say complement and others refute) the recently published and immensely popular book *The Virginian,* by the Philadelphia writer Owen Wister.[4]

When Wildman sat down to interview Remington, the artist wanted to speak about his mission as an artist. He claimed that imagination was the nucleus of artistic vitality, that "big art" was to be found in re-creating the essence or "the spirit of a thing, and the small bronze—or the impressionist's picture—does that." His audience was primarily male, he observed, and his favorite subjects were horses and the western plains. Although he enjoyed painting Adirondack sunsets, he could not sell them, lamenting that people had him "pigeon-holed in their minds"; they "want horses, cowboys, out-west things—won't believe me if I paint anything else." Reiterating the theme of his novel, Remington concluded that progress, exemplified by "the march of the derby hat," constituted the world's biggest crime against nature, humanity, and art. "White man spoils nature," he grumbled, "by trying to improve on it."[5]

In September 1903, six months after the profile of Remington appeared, Russell granted a similar interview to Sumner W. Matteson, a Great Falls photographer and writer. The resulting story appeared in *Leslie's Weekly* the following spring, in March 1904, and represented one of the earliest bits of national coverage for the man Matteson affectionately referred to as "the Cowboy Artist." [6]

Matteson described Russell as "stolid and indifferent" to strangers but glowing with warmth among friends, of which he enjoyed a great number. His was a unique talent that was molded by natural innocence and was quickly maturing in his craft, which he had been practicing seriously for only about seven years. His wife, Nancy, guided his natural abilities as an artist; devoted and mutually supportive, they were a "truly beautiful" couple. Russell's art drew its themes from his colorful past on the range, and he had been encouraged by many to "cultivate his natural art as a plains historian." For exercise he relied mostly on his horse, having "no desire to venture where his horse cannot carry him." Nonetheless, Matteson, acknowledging a certain level of physical ability, considered him "adept with a rope." Russell's list of credits contained no novel, but he was widely acclaimed as a raconteur. His mixture of humor, folklore, history, and personal recollections

4. Davis and Sanford, *Portrait of Frederic Remington,* ca. 1902. Photograph, 7⅞ × 5 inches. Frederic Remington Art Museum, Ogdensburg, N.Y.

made him "a prince of storytellers," and in the next few years several of his tales would find their way into print.[7]

Matteson did not address the issues of the clash of East and West or the spoliation of the frontier by the intrusion of whites, but these were favorite subjects of Russell's and were raised indirectly when Matteson focused his attention on one of the artist's earliest masterpieces, *Waiting for a Chinook*, painted in 1886. This little painting depicts the dramatic and tragic end of the open-range cattle industry in southern Montana, ostensibly the result of bitter, late-winter weather, but Russell and almost everyone else knew that the cause was avaricious overstocking of the range.

Regarding his art, Russell was, as customary, rather reticent. Matteson photographed him painting an oil, *A Rough House* (1903), which showed a shoot-out at the front door of a small-town saloon, a theme Russell enjoyed exploiting for its drama and action. He had just finished modeling what would become his first bronze, *Smoking Up* (figure 6). It held striking similarity to one of the figures in Remington's most ambitious early sculptures, *Coming Thru the Rye* (figure 12), which had just recently been copyrighted and was being enlarged for exhibit at the 1904 world's fair, the Louisiana Purchase Exposition, to be held in Russell's hometown of St. Louis, Missouri. Russell himself was preparing work to be entered in the same world's fair, including his watercolor *Roping a Grizzly* (figure 13). His rollicking "figures and somber colorings of the ranges and vast reaches," Matteson concluded, "made him the equal, if not the superior of a few really good workers in this most deserving field."[8]

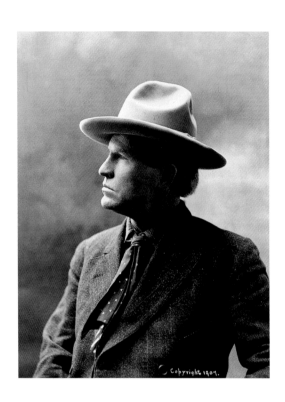

5. A. O. Gregory, *Studio Portrait of Charles M. Russell*, 1907. Photograph, 9¼ × 7¼ inches. National Cowboy Hall of Fame and Western Heritage Center, Oklahoma City, Okla. Joe DeYong Collection.

DUELS IN THE PRESS

Even before Russell's fame reached national audiences, he was being compared in the press with Remington and Remington's arch rival, Charles Schreyvogel. A relatively new player on the scene, Schreyvogel was among the "few really good workers," although perhaps somewhat less significant, while Remington was the gauge by which success in the field was measured. *The Denver Republican* had run a feature on Russell in August 1903, noting that Russell's work was frequently likened to and measured against Remington's.[9] With respect to technical surface treatment, or finish, Russell found himself out of Remington's

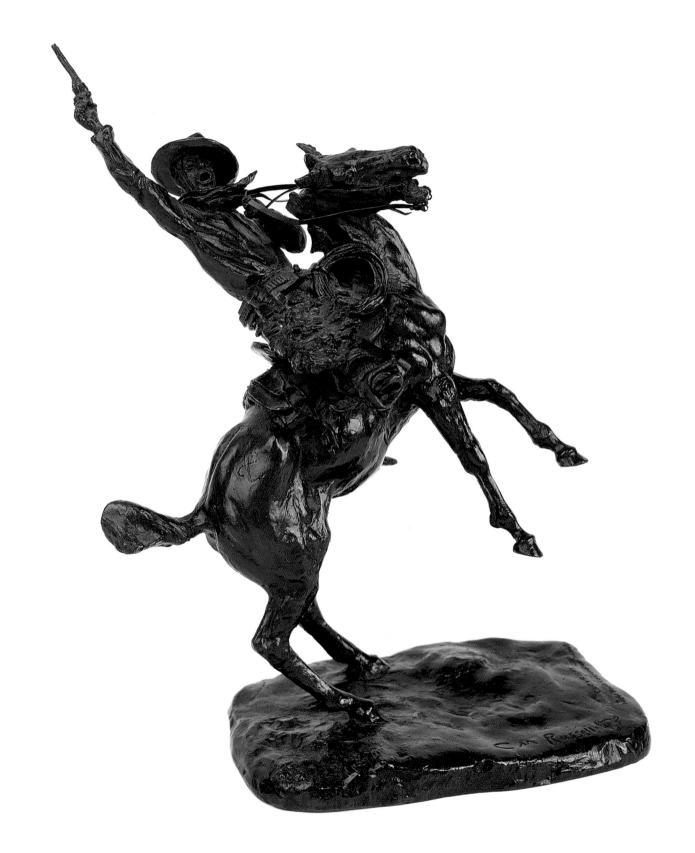

league. The technical aspects of Russell's art would improve with time, according to the Denver article, and for raw vigor and love of subject he had no equal. The writer extolled the potency of Russell's untutored style, concluding, "as his paintings stand to-day, their freedom and strength will give them a place in the best company."[10]

EAST VS. WEST

What Russell needed, along with his wife's encouragement, some determination, and a full portfolio to bolster his odds, was a chance to rub shoulders with that "best company," learn from them some of the technical tricks of the trade, and receive national exposure for his efforts. He and Remington had much in common, and it would have seemed logical that the two could have shared much.

As noted earlier, there is evidence that Remington and Russell may have met at least once—during the Russells' second trip to New York City in late 1904—but a relationship never flourished.[11] Remington was at the top of his game and would probably have felt that Russell's art was a bit rough, although their subjects were certainly compatible. Remington could also be haughty. The Russells would not have fit comfortably within his social circle, and Russell, despite his proclivities as a bar hound, would have been out of place at the Player's Club or Salmagundi, where Remington sipped whiskey and bantered with his cronies. Whereas John Marchand and some of his friends were anticipating being Russell's friend and mentor, Remington would not have been interested. He probably did not feel the pinch of competition from Russell that Schreyvogel had presented, so there was no sense, at first, of resentment. In addition, Remington simply had a busy life of his own.

Others, however, saw an opportunity to gain by comparing the two artists and forcing the issue of their differences as individuals and artistic interpreters of the West. Ironically, the first of the groups to exploit the situation was one that Russell particularly disliked but that could not be ignored: western promoters, ranging from the press to the politicians. As early as 1901, the *St. Louis Post Dispatch* in an article entitled "Cowboy Artist, St. Louis' Lion" touted Russell, its native son, as "the man who may rival Remington." In what was termed "a new Western art culture," Remington was referred to as an "idealist," while in contrast Russell was a "realist" who knew "his Indians, his plainsmen, his

6. Charles M. Russell, *Smoking Up*, 1904. Bronze, 13 × 7 1/2 × 5 inches. Frederic G. and Ginger K. Renner Collection, Paradise Valley, Ariz.

broncho and cayuse and his cattle. All the finish his art shows has come to him intuitively during the progress of its natural development. His gift is purely negative. Not one hour was ever spent in a studio."[12]

The *Denver Times* offered much the same regional slant a year later. Russell's works were unknown in the East, the article pointed out, acknowledging that Russell "cannot make a better portrait than [Elbridge Ayer] Burbank [1858–1949], or a truer pen sketch than Remington. He has, however, a greater range than either of these artists; he does both pen and ink and water color and oil work. His compositions are wide-embracing, due to his varied experiences. For twenty years, ever in sight of a teepee, he has actually punched cows in the West."[13]

In 1904 four of Russell's works were exhibited at the Louisiana Purchase Exposition, three in the Montana Pavilion and one in the Fine Arts Pavilion. The state of Montana, to bolster its stature in the aesthetic realm, was holding up Russell in a quasi-official way as Remington's equal or greater. Thomas Carter, a U.S. senator from Montana, pulling up Russell on Remington's coattails, made the following boast:

I doubt not that those who may go through these rooms from time to time during the progress of the Exposition will surmise that some of the pictures are from the brush of Remington, or some artist of like renown. But not so, those who see animals in action, and some of the most captivating artistic work of the age on these pictures will find that an ordinary cowboy from the City of Great Falls, in our State, is shown to be the peer of Remington, and one of the artists destined to live in the history of art within the lines he has made his own.[14]

"The effete east has her Remington," puffed the *Butte (Mont.) Miner* in 1903, and "the glorious west has her Russell."[15] This sectional braggadocio embarrassed Russell and probably never reached Remington. But Montanans doubtless felt that they had an artist on whom they could deservedly harness their pride.

FAKING THE WILD WEST

State and regional boosterism was one thing, but some artists saw an opportunity to exploit the evolving division of opinion to enhance their own stature. By taking sides with the Russell camp, they could ride the cresting wave and reach the shore of success along with him. This seems to have been the motivation of the photographer and

7. Frederic Remington, *The Discovery*, 1908. Oil on canvas, 26 1/2 × 39 1/2 inches. Gilcrease Museum, Tulsa, Okla.

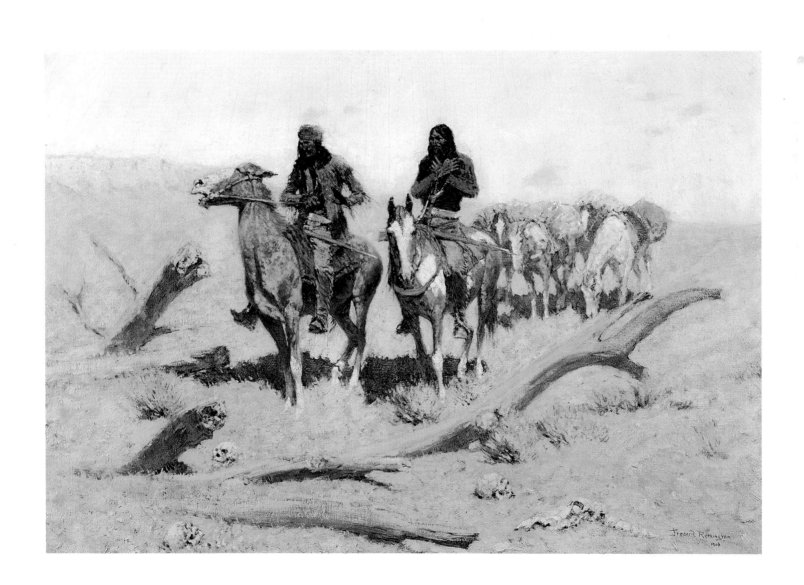

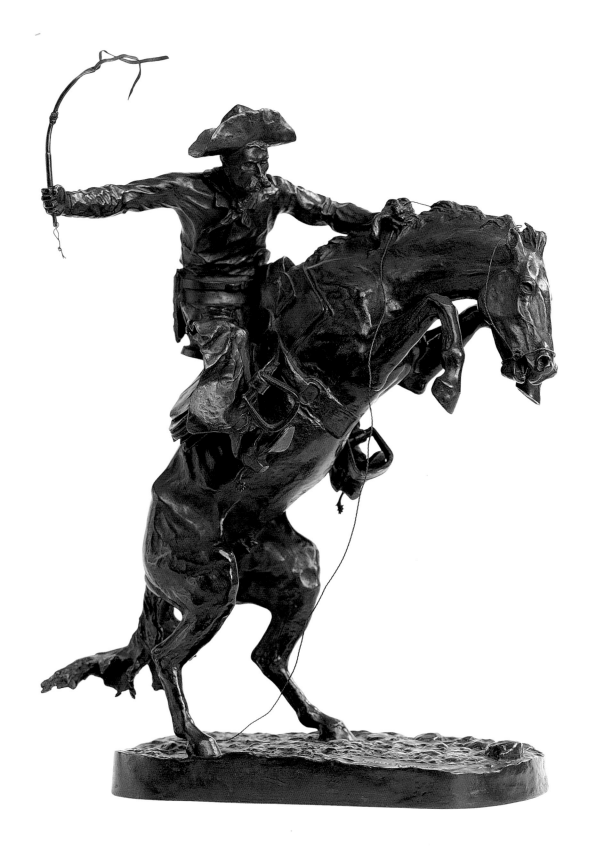

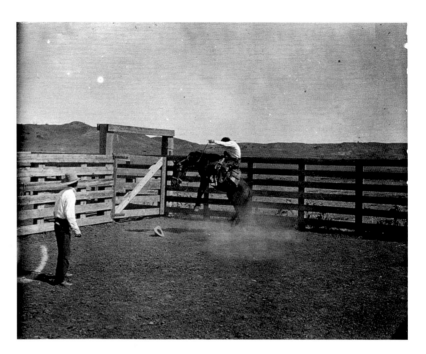

9 (right). Erwin E. Smith, *A Pitching Bronc*, 1907. Contact print photograph, 4 × 5 inches. Nita Stewart Haley Memorial Library, Midland, Tex.

8 (opposite). Frederic Remington, *The Broncho Buster*, 1895. Bronze, 24 × 18⅞ × 11⅜ inches. Collection of Glenbow Museum, Calgary, Alberta, Canada.

would-be sculptor Erwin E. Smith (1884–1947) of Bonham, Texas. In an article published in 1904 in the *Great Falls Daily Tribune*, Smith questioned Remington's designation as a credible pictorial interpreter of western life, thus maligning him among the men he portrayed, particularly cowboys.[16]

Smith, an art student at the school of the Museum of Fine Arts in Boston during these years, enjoyed favorable notice for his remarkable photographs of ranch life that were featured in the Boston papers as early as 1908. Like Russell, he was proclaimed a "sure-enough cowboy," and his photographs deserved national attention (paradoxically, many of these were compositionally based on Remington designs). In one *Boston Herald* article, Smith promoted himself as a true depicter of a vanishing scene. In Texas, he claimed, the large ranchers were on the brink of extinction as a result of barbed wire, plowboys in bib overalls, and bankers willing to stake farmers to a try at working the land. His own importance, he suggested, was in preserving the scene for posterity.[17]

In the same article Smith was emboldened to split western artists into those who saw and depicted the real thing out west and those whose observations were either secondhand or flawed by lack of attention to detail. He placed himself and Russell in the former category, while

Remington was held up as one of the more slipshod variety. Comparing his photograph *A Pitching Bronc* (figure 9) with Remington's 1895 bronze *The Broncho Buster* (figure 8), Smith proceeded to outline a litany of mistakes in the latter work: a horse would never tuck its forefeet up under its chin when bucking, a rider would not allow his foot to slip out of the stirrup, a rider would not hold a quirt (a riding whip) with one hand and the horse's mane with the other.[18] Russell was the one to look to for the correct bronco pose, Smith proclaimed, although he must not have seen some of Russell's watercolors of the period, which in some respects are remarkably close to Remington's rendition.

In the early 1900s Smith conspired with a couple of partners to bring up himself and Russell while bringing down Remington. One cohort was his drawing instructor, Philip Leslie Hale (1865–1931), a painter and critic who for some reason disliked Remington and was willing to step forward and take him to task as a poor artist. An exhibition of Remington's paintings at Boston's Dole and Richards Gallery in early 1909 provoked Hale to a vitriolic attack in the *Boston Herald*. Remington's colors were "lurid," his nocturnes nothing more than "monochromes," his figures "not very well done," and his action paintings "rather queer and violent." "If truth to nature and good workmanship are the first essentials of good paintings," Hale concluded, "it may be that one would not be disposed to take these things very seriously as paintings."[19] It was a critique that got Remington's attention. He huffed to his diary a few days later: "One P. Hale in Boston Herald gives my paintings … a turn over. He must have liked the frames since he didn't put the acid in them…. I never got such a roasting in my life…. I fear Boston will never enjoy Freddie again."[20]

Fortunately for Remington, Hale's assessment was buffered a few weeks later when Giles Edgerton, writing for *The Craftsman*, countered Hale's contemptuousness with the judgment that Remington was "at present one of the most unalterably representative American painters and sculptors, which the nation can boast. He is in fact one of the few men in this country who has created new conditions in our art, and must be reckoned with as one of the revolutionary figures in our art history."[21]

Smith then engaged the western writer Emerson Hough (1857–1923) in further efforts to discredit Remington. He encouraged Hough, who had worked with Remington on projects in the past, to

10. Frederic Remington, *No More He Rides*, cover illustration for *Collier's Weekly*, September 14, 1901. Photomechanical reproduction of oil on canvas. Frederic Remington Art Museum, Ogdensburg, N.Y.

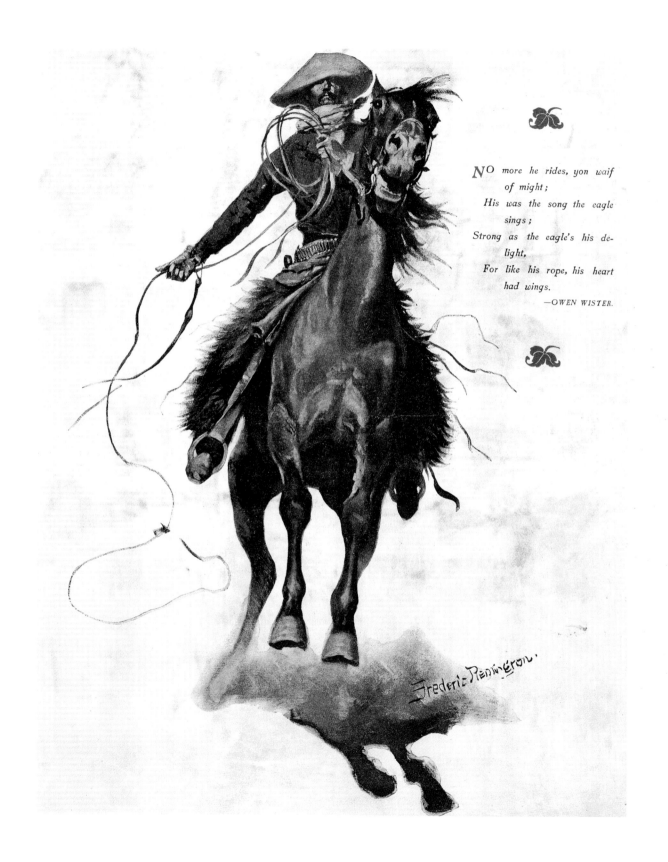

NO more he rides, yon waif
 of might;
 His was the song the eagle
 sings;
Strong as the eagle's his de-
 light,
 For like his rope, his heart
 had wings.
 —OWEN WISTER.

11. Charles M. Russell, *Roping a Maverick*, ca. 1896. Bookplate from Emerson Hough's *The Story of the Cowboy* (1900 edition). Photomechanical reproduction, 3½ × 5⅞ inches. Peter H. Hassrick, Norman, Okla.

expose Remington as the ringleader among several eastern artists who had "positively ridiculous" notions about the cowpuncher and his life.[22] To craft his argument Hough picked up on the "nature faker" controversy then raging in the public press. In an interview published in the September 1907 issue of *Everybody's Magazine*, President Theodore Roosevelt (1858–1919) attacked the writer Jack London (1876–1916) for idealizing and anthropomorphizing animals in his writings—in effect, humanizing them. This gave a false picture of what nature really was, Roosevelt contended, and demeaned serious study and revelation of the facts that could inform and enrich the public's understanding of the world around them.[23] Several years earlier, in 1903, the nature writer John Burroughs had denounced the artist-naturalist Ernest Thompson Seton (1860–1946) on similar grounds. There was a good deal of finger pointing and righteous posturing, all part of the Progressive Era's pursuit of truth. Hardly had the flying fur and feathers of the nature controversy begun to settle when the issue of western art came into question.

Hough wrote to Smith in the summer of 1907: "If I can do anything to show up those western fakers with pen and brush it will give me very keen personal delight. It has always been my belief that the West has been described, for the most part, by the very men who know the least about it."[24] Hough himself had lived in the West for only a year and a half in the mid-1880s, when he practiced law and journalism in White Oaks, a small mining town in New Mexico. As a result of that brief sojourn, he had written three books on the West, one of which, *The Story of the Cowboy* (1897), had been illustrated in part by Russell, who provided six illustrations.[25] (The two men, who had a friendly relationship, did not actually meet until 1910.) The book had sold briskly, going through several editions in the decade since its publication. However, Hough's most recent literary endeavor, *The Story of the Outlaw* (1907), was faring poorly in the marketplace and had, in fact, become a financial flop for the author. Hough, in an effort to promote himself and drum up business for his book, took on the task of muckraker for the western art business. Remington was to be his target. "Met Emerson Hough (at Player's Club) and he has written an article for Colliers on *Western Faking*—in which [I] judge he gives me a roasting," Remington scribed in his diary on April 6, 1908. It made him "uncomfortable," he added, especially coming from one of the most "disagreeable people" he had ever met.[26]

The article "Wild West Faking" appeared in the December 19, 1908, issue of *Collier's Weekly*, just in time to boost Christmas sales for Hough's book and spoil the holidays for Remington. Hough pulled Russell into the fray—whether with or without his knowledge is unknown—by referring to the "cowboy artist's" critique of Remington's painting *No More He Rides* (figure 10), published in 1901. "That fellow in the picture," Hough quoted Russell as saying, "may be able to handle a rope with his quirt hanging on his right wrist while he's roping; but I have never seen it done in real cow work myself." Hough contended that almost every western work by an eastern artist suffered from some similar "technical fault" or exaggeration but zeroed in on Remington: "[I]f Mr. Remington today wanted to add a cubit to the tail of the American bison, or to establish a Western horse with five legs, he certainly could make it stick." For Hough, Remington was the veritable "progenitor" of a whole school of fakers.[27]

These were easy shots to fire, but they hit home hard. On the day that issue of *Collier's* reached Remington's hands, the artist wrote in his diary of great "discouragement": "There is one thing a man who does anything in America can figure on—a d_____ good pounding. It seems to be one of the penalties of achievement." He had been working on a cowboy painting all morning, trying to get effects of dawn's light just right, but after reading Hough's invective he gave up on the canvas and "burned it up together with other failures." Over the next several days he became almost paranoid, wishing, for example, that he could find and destroy all his old paintings. "My old enemies come to haunt me. I am helpless. I would buy them all if I were able to burn them up," he wrote in his diary on December 22. By year's end, not able to find many of his old works, he had destroyed more than twenty-five recently painted canvases.[28]

Book sales for Hough's *Story of the Outlaw* did not improve, although his *Story of the Cowboy* continued to be acclaimed for its authentic portrayal of range life. Philip Ashton Rollins's definitive reevaluation of the topic, *The Cowboy* (1936), acknowledged Hough's factual contributions to the literature.[29] And although Hough and Russell were correct in their appraisal of some of Remington's works, their own treatments were not entirely correct. *Roping a Maverick* (figure 11), one of Russell's spirited and engaging illustrations for Hough's cowboy book, presented a classic flaw that Remington had brought to the attention of the art community in the late 1880s.

12. Frederic Remington, *Coming Thru the Rye*, 1903 (cast posthumously, ca. 1912–13, Roman Bronze Works). Bronze, 28 × 24 × 17 inches. The Cornish Colony Gallery and Museum, Cornish, N.H. Collection of Peter and Alma Smith, Cornish, N.H.

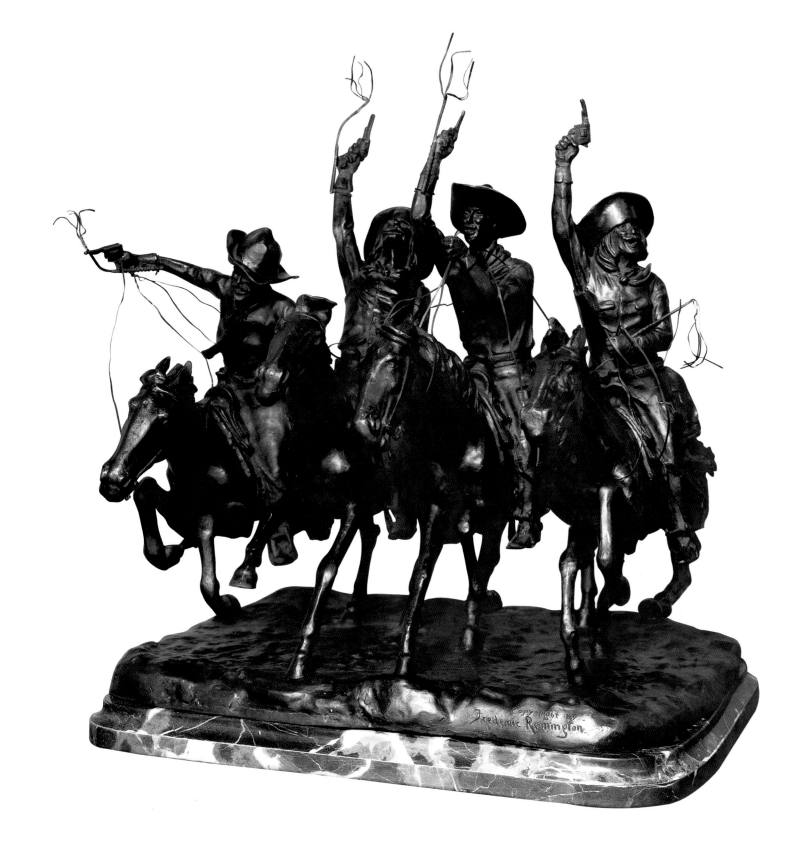

Copyright by Frederic Remington

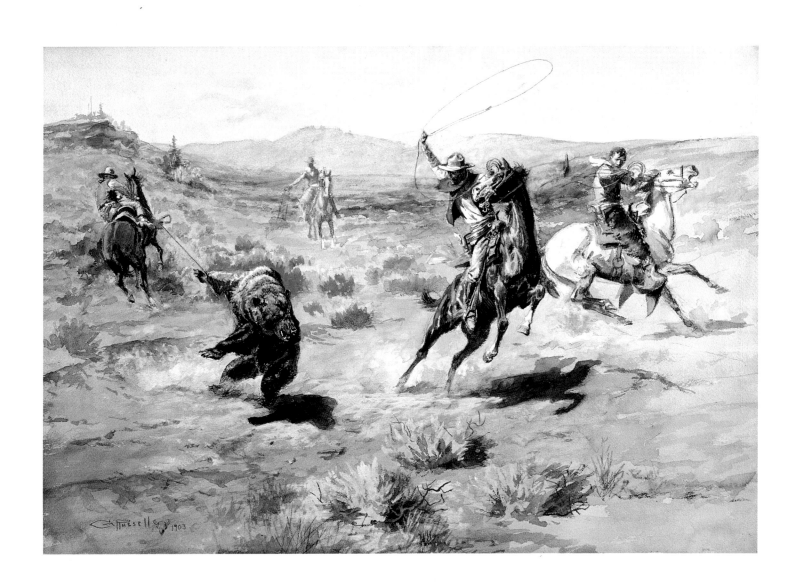

Horses do not run with their legs stretched out before and behind simultaneously, as their carousel counterparts do.[30] This was an artistic convention adopted from European art and one that Russell, the consummate horseman, should have known better than to use, especially since he claimed truth in art as his game. Ultimately Hough was hobbled by his own insistence on authenticity, and he is remembered essentially as a documentarian rather than as an important literary figure. His biographer, David Nordloh, lamented that Hough's fiction was always criticized too narrowly as if the only thing that mattered in his work was accuracy.[31]

REPERCUSSIONS OF RIVALRY

The rift between two of America's greatest western artists, then, occurred not because Russell invaded Remington's geographical territory—his hometown—or even his artistic territory. It was not because Russell and Remington ever clashed; they never gave each other that much thought, although Russell throughout much of his career patterned many of his compositions after Remington's and thus owed him a profound debt. And it was not even because Russell began to fill many of the illustration orders that had previously been Remington's. In 1903 Remington, who had previously worked for a number of magazines producing hundreds of illustrations a year, signed an exclusive contract with *Collier's* to provide only twelve illustrations a year. By 1908 he had abandoned illustration altogether for a career in painting, thus leaving the door open for Russell to pick up where he had left off.

What appears to have happened is that Remington and Russell became pawns in a game designed by others for the benefit of others. The manufactured controversy may have helped Russell achieve prominence, but at the same time it impaired his reputation. Because he was so publicly embraced by Smith and Hough, who asserted that artistic credibility depended primarily on accuracy of detail, Russell was considered a slavish imitator and not taken seriously as an original, creative force in American art for many years. Even today he suffers profoundly, if unjustly, from association with the school of thought that accuracy in art is all-important.

The practical skills and aesthetic perspective that Russell garnered

13. Charles M. Russell, *Roping a Grizzly,* 1903.
Watercolor, 19 1/2 × 28 1/2 inches.
Buffalo Bill Historical Center, Cody, Wyo.
Gift of William E. Weiss.

from his exposure to eastern artists and that began to inform his art within a few years of his first New York trips elevated him to a status on a par with Remington as a significant contributor to the history of American art. His sculpture was inventive and vigorous well beyond other practitioners of his generation. His paintings at their best evinced an aesthetic sophistication, a stylistic originality, and a technical facility that equaled the best painters of his day.

Smith derided Remington for being only an artist and inadvertently damned Russell for being only a cowboy. "Well," wrote Smith in 1909 about Remington's sculpture *The Broncho Buster* (figure 8), "the man that did this is an artist. That is evident; but it is equally evident that he is no cowboy. Neither is he a rider, if I am right in believing that his [bronco buster's] one hand is grasping the horse's mane and the other fist clutches the quirt." Despite the fact that Russell in *Bronco Busting* had depicted his cowboy crony Bob Thoroughman in essentially the same posture, Smith dubbed the Montana artist as the "only artist who has truthfully caught the cowboy and painted him in action and as he is."[32]

The irony is that the reputations of Remington and Russell, two true artists, were so clouded, at least for a time, by two faltering artists, Erwin Smith and Emerson Hough. Smith, after years of studying art in Boston and nurturing a dream to be a sculptor, could never take a real step in that direction, fearing exposure as nothing more than a rather derivative documentary photographer, and Hough, in spite of his longings, failed to become a creative force in American literature. Yet in their efforts at self-aggrandizement, they succeeded in shaking Remington's self-confidence and persuading many that his ascendant place in American art was ill founded. Similarly, they persuaded Russell and most of his contemporary and future admirers to accept for him a diminished role. Partly out of self-effacement, partly out of coyness, and partly out of his own belief in the arguments of Smith, Hough, and their ilk, Russell continued throughout his life to deny that he was really an artist. "I am just an illustrator," he protested, and not even, according to him, among their top ranks.[33]

Remington took Hough's denunciation to the grave in 1909, while Russell was forced to live with the embarrassing controversy for his many remaining years. Even in the obituary of Remington that ran in the *Great Falls Daily Tribune*, there was no room for charity in the matter:

14. Frederic Remington,
Thus the Birch Canoe Was Builded ..., 1889.
Oil on canvas en grisaille, 19 7/8 × 28 inches.
Houston Museum of Natural Science, Houston, Tex.

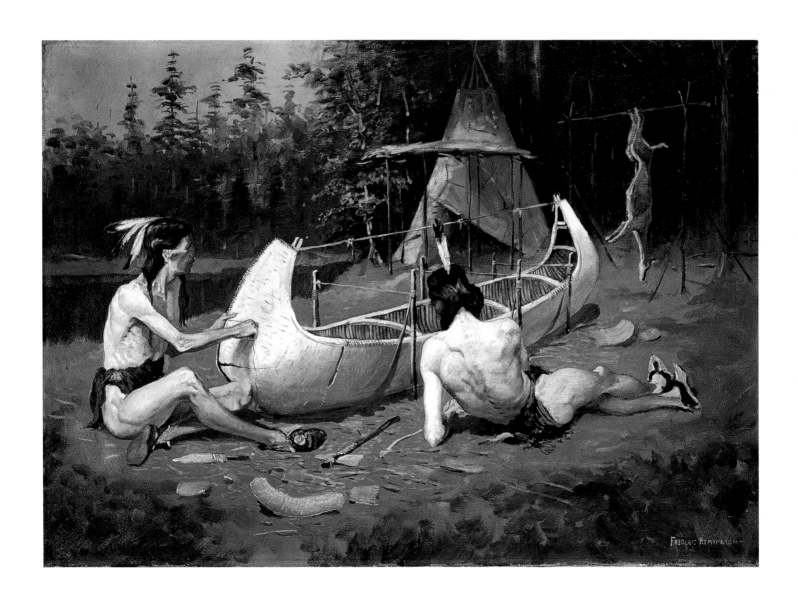

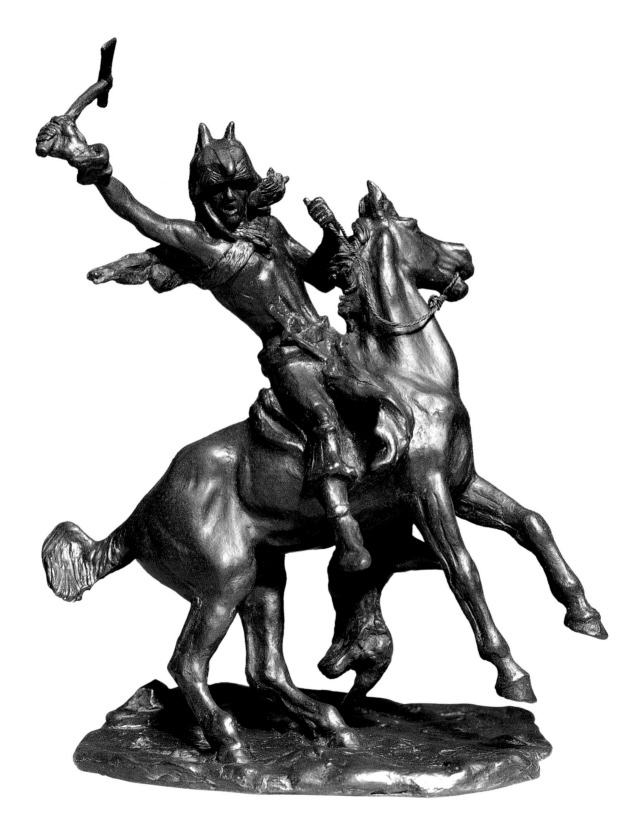

15. Charles M. Russell, *The Cryer,* ca. 1926
(cast 1929–34, California Art Bronze Foundry).
Bronze, 11½ × 8 × 6 inches.
National Cowboy Hall of Fame and Western
Heritage Center, Oklahoma City, Okla.

When Frederick [sic] died last week a great many eastern publications and newspapers, in mentioning the artist and his work, lamented that the greatest of western artists had passed away. Statements of this nature are to be expected from many eastern editors whose western horizon is limited by Chicago, and whose knowledge of things western are limited by what they have read of the west from the pens of eastern writers and pictures of the west by eastern artists.

Such statements, however, should not be allowed to go unchallenged in the west and particularly in Montana. For all the world knows that Remington, great artist that he was, can never be considered even in the same class with Charles M. Russell. And in the opinion of many westerners, he was not even second to Russell as a western artist. It is true that there are many other western artists who have caught the spirit of the west on their canvases with more fidelity than did Remington. Remington never lived in the west, notwithstanding statements to the contrary, and all that he knew of the western country he gained from ranches, army posts and Indian camps. His pictures show that the knowledge of the western types that he gained was superficial. Remington was never able to picture the northwestern Indian, but fidelity to nature was not necessary to make his pictures of the west convincing to easterners.

In an issue of *Collier's* magazine published last fall, an article by Emerson Hough, one of the best known writers on western subjects, stated emphatically that there was only one man who could depict the west and that that man was Russell. *Collier's* is the magazine in which most of Remington's work has appeared in later years. Mr Hough pointed out in detail the flaws that exist in Remington's western pictures.[34]

After Russell died in 1926 and the dust from the panegyrics had settled a bit, the fabled American sculptor Gutzon Borglum (1867–1941), the brother of Solon Borglum, stepped forward in a brilliant effort to settle the feud. In a farewell to his fellow artists he wrote the following:

Russell has been compared to Remington. We know he disliked this. I did not know Russell personally and I cannot say what he thought of Remington. But let us say this: no two men can be compared or paired, as does the average mind, as a process of dismissal … let us be grateful we have them both, each in his span, giving us their separate record of a life that practically had gone with them.[35]

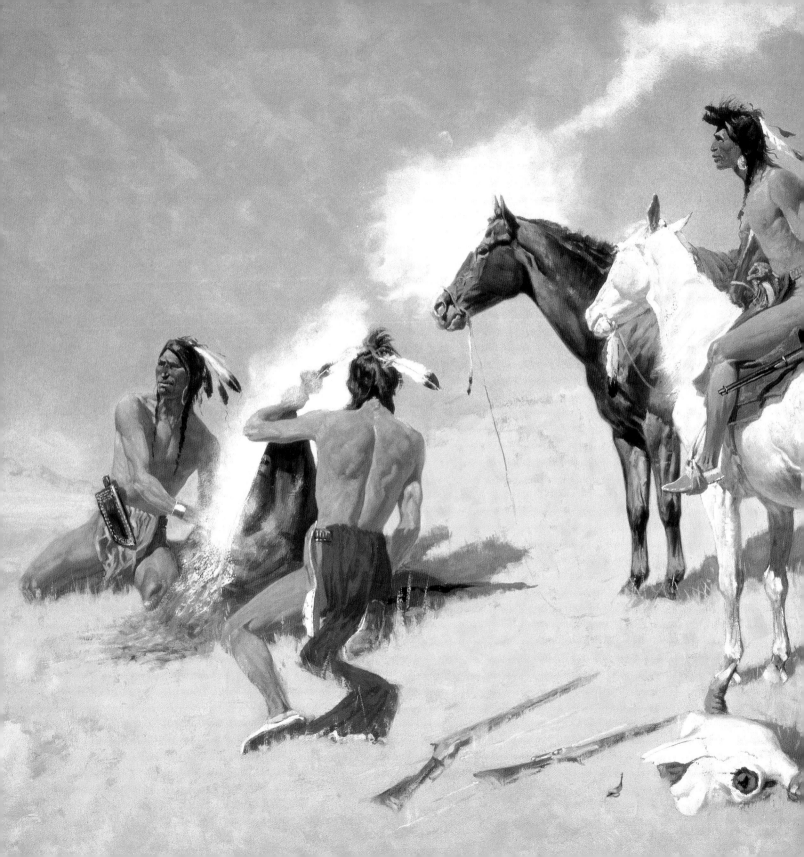

Portraits of the Artists

Both Remington and Russell were born into prosperous, conservative families and raised in the post–Civil War era when the mountains, vast prairies, and distant Pacific shores invited the country to look west for economic and spiritual renewal. Americans could venture personally or vicariously beyond the Mississippi, achieving individual satisfaction while fulfilling the nation's Manifest Destiny and thus helping reclaim the collective national identity recently weakened by civil strife. The nation, looking westward, saw the burgeoning of communities such as Denver, the completion of the transcontinental railroad, the agricultural development of the Great Plains, and the end of the tragic Indian wars. Children's attentions were drawn west by tales of adventure such as dime novels by Evastus Beadle or Ned Buntline, while more serious readers, young and old, could immerse themselves in the region's history through books by Francis Parkman and Josiah Gregg. There was certainly enough in all this to capture the fancy of Fred Remington of Canton, New York, born in 1861, and Charlie Russell of St. Louis, Missouri, born in 1864.

Several thoughtful and perceptive biographies have detailed the two artists' childhoods and the pull that the West had on each.[1] They

Remington in *The Smoke Signal* (figure 78) and Russell in similar works used the Indian smoke signal to symbolize native resistance to Anglo invasion of their land. Both tried to reflect what they thought of as a native voice.

both enjoyed reasonably good secondary educations, although Russell never finished high school, and both attended military academies (Remington for two years at Highland Military Academy in Worcester, Massachusetts, and Russell at Burlington College in New Jersey, north of Philadelphia, for about half a year). Each had a profound affection for his father. Seth Remington was a Republican journalist and cavalry officer who inspired his son creatively and politically while imbuing him with a love of horses and the military, reflected in, for example, *An Incident of the March* (figure 18), done in 1891. Charles Silas Russell was a businessman remembered primarily for his willingness to read books to his children and his capacity to smoke cigars to their bitter end and consume whiskey three times a day.

Most important, the parents recognized and encouraged the nascent artistic spark that glowed in each boy's heart. Remington enrolled in Yale's School of Fine Arts, where he spent a year and a half until his father's premature death in 1880. Russell was offered but declined similar art lessons. Yet when as a young man he finally determined to become a serious artist, it was his father who pressed his cause and later helped get his art accepted, at least in the St. Louis area, with private commissions, gallery exhibitions, and exposure at the 1904 world's fair. However, their passion for art came from their mothers. Remington's mother reportedly passed time decorating china teacups, and some of her artistic facility may have rubbed off on her son, while Russell's mother's family included talented jewelers and craftspeople.[2]

16 (above). Photographer unknown, *Portrait of Russell as a Cowboy in Montana*, ca. 1884. Photograph, 7 3/8 × 4 1/2 inches. Taylor Museum, Colorado Springs Fine Arts Center, Colorado Springs, Colo. Britzman Collection.

FOLLOWING IN EARLY FOOTSTEPS

In the spring of 1880, Russell, not yet sixteen years of age, persuaded his parents to let him go west to work on a ranch. A family acquaintance, Wallis "Pike" Miller, owned a small sheep operation in the Montana Territory and offered Russell a job as a herder. Although the job in itself was unsatisfactory, it was the start of his lifelong relationship with the northern Plains and Rocky Mountains. A little more than a year later, in August 1881, Remington also headed for Montana. His hometown newspaper, the *St. Lawrence Plaindealer*, announced that he intended "to make trial of life on a ranche."[3] "At nineteen I caught the fever to go West," he recalled years later. Russell had been looking to

17 (opposite). Charles M. Russell, *The Broken Rope*, 1904. Oil on canvas, 24 × 36 inches. Thomas Petrie, Denver, Colo.

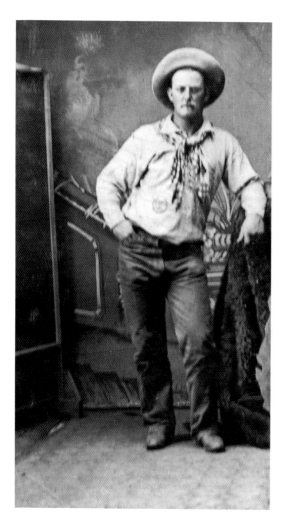

19 (above). Photographer unknown, *Portrait of Remington as a Cowboy in Kansas*, 1883. Photograph, 3 × 1½ inches. Frederic Remington Art Museum, Ogdensburg, N.Y.

18 (opposite). Frederic Remington, *An Incident of the March*, 1891. Pen and ink wash on card stock, 16¾ × 21½ inches. Carnegie Museum of Art, Pittsburgh, Pa. Andrew Carnegie Fund, 1906.

escape from St. Louis into a world of adventure. Remington said that his "idea was to become rich,"[4] although he too was running away—from a broken romance. His first proposal of marriage to Eva Caton had been spurned (although she would ultimately become his wife). Neither young man suggested art as part of his motivation.

Neither was especially inspired by his first encounter with the West. Russell hated his work with sheep and quit the job. It was only by chance that he hitched up with Jake Hoover, a hunter and mountain man who through his mentoring and financial generosity provided the rationale and wherewithal for Russell to remain in Montana. Remington's only written recollection of his first trip to the West was an evening spent with a discouraged wagon freighter who lamented the West's being taken over by the railroads and mechanical cord binders. "The wild riders and the vacant land were about to vanish forever," Remington wrote.[5] But it had not vanished yet. Remington returned home within a few months, but Russell, still in Montana, eventually found employment in the cattle business, working beside the wild riders of that vacant land for more than a decade. In the spring of 1883 Remington went west again, setting himself up in the ranching business. He could not afford a cattle spread, but a Kansas sheep operation was within his reach; he ran it for one year and learned to enjoy the experience.

As young men, Remington and Russell were similar in many ways, both adventuresome and tough. Russell was determined, obstinate, and, according to an autobiographical account promoted after 1900, "considered pretty ornery."[6] Remington had played football at Yale, was a boxer, and was known as a prankster. Neither fellow was very farsighted. Russell went from job to job, watching over horse herds as a night wrangler and working for as many different outfits as opportunities presented themselves. Not until the open-range cattle business had burned itself out in Montana did he begin to shape in his mind a career for the future. Remington gave up ranching after about a year and married his boyhood sweetheart, Eva. They moved to Kansas City, where, proving his lack of business acumen, Remington proceeded to squander his inheritance on poor investments. Economic pressures forced him in 1885 to decide on a professional career, as with Russell after 1892. Both chose art.

What Remington and Russell wanted out of the West as young men was essentially the same thing: to actualize the myth of the frontier as

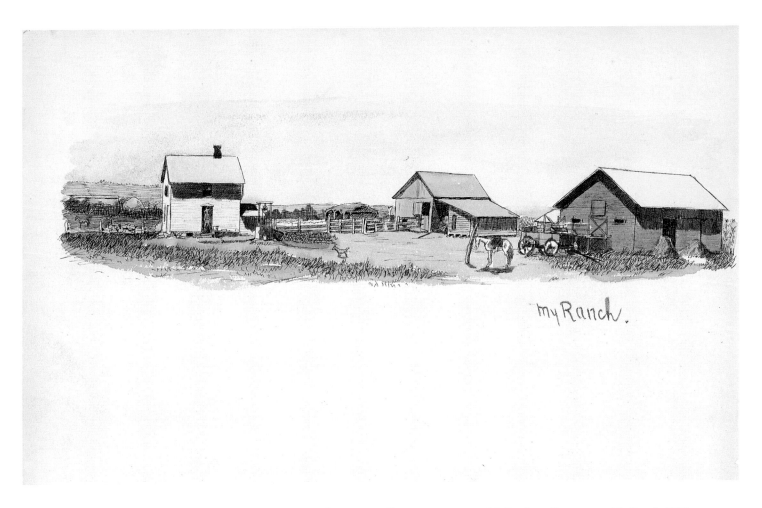

my Ranch.

a place of self-discovery and freedom from social restraint. Remington and probably Russell too had read Josiah Gregg's *Commerce of the Prairies*, which had been popular since its publication in the mid-1840s. Gregg had taken to the plains after having "striven in vain to reconcile [himself] to the even tenor of civilized life in the United States." Although Remington was more gregarious than the socially diffident Russell, Gregg's claim that "the wild, unsettled and independent life of the prairie … makes perfect freedom from nearly every kind of social dependence an absolute necessity" would have been compelling for each.[7] For Russell, going west allowed him to escape parental pressures and the burdens of school; for Remington, it fulfilled the standard expectation of Yale men and provided a retreat from a

20. Frederic Remington, *My Ranch*, 1883. Watercolor, 9 × 11½ inches. Frederic Remington Art Museum, Ogdensburg, N.Y.

21. Charles M. Russell, *Where I Learned
the Diamond Hitch—The Old Hoover Ranch
on the South Fork of the Judith*, 1917.
Pen and ink, 6 3/4 × 11 5/8 inches.
Wiley T. Buchanan III, Washington, D.C.

hurtful romance. For both the desire was the same: to escape into a world unrestrained and apart.

A naive watercolor that Remington produced of his Kansas ranch in 1883 and a later drawing by Russell indicate the mutual pleasure of their situations. Remington's *My Ranch* (figure 20) and Russell's *Where I Learned the Diamond Hitch—The Old Hoover Ranch on the South Fork of the Judith* (figure 21) picture tidy if remote establishments that speak of a sunny, quiet life in surroundings that, although otherwise undramatic, allowed them the freedom to begin to realize their youthful aspirations to be cowboys.

Like most young men who went west in this era, these two would-be cowpunchers, attired in their western garb, found their way into

photography studios, where they posed jauntily before painted back-drops (figures 16 and 19). With hats tipped back and hips cocked to one side, they stare directly at the camera as if to challenge any question about the veracity of their newly adopted personas. One in Peabody, Kansas, the other probably in Helena, Montana Territory, each was hungry for recognition as a cowboy, that heroic individual seeking epic forms of action in a wilderness free of restraint—or, as Wallace Stegner would suggest, fulfilling the dreams of just about every adolescent male in America in the late nineteenth century.[8]

As these two young men strove to shape their identities and prove their manhood in the West, they were also exploring vague notions of someday becoming artists, playing out lessons learned from generations of frontier artists who preceded them. Especially in the decades before the Civil War, artists ranging from George Catlin (1796–1872), whom Remington professed to admire, to the German train painter Carl Wimar (1828–62), an acknowledged favorite of Russell's, established a rich store of pictorial iconography on which later followers patterned their interpretations. Remington and Russell were quick to adapt from the past, drawing readily from that collected reservoir of mythic constructs. Both Catlin and Wimar not only relished the artistic challenge of recording memorable and significant images on canvas and studying their subjects with care and dedication; they equally cherished the pure adventure of the western experience. Wimar had himself photographed as a mountain man (figure 22) in 1858 after he had returned from a six-month trip up the Missouri River, sketching and photographing the Indians. Catlin portrayed himself as a buffalo hunter around 1850 using one of Samuel Colt's new revolving pistols (figure 23).

The spirit of adventurous enterprise set western artists apart from others and, as the critic Henry Tuckerman reported in 1867, clearly became recognized as one of those elements that gave special zest to "American artist-life" in general.[9] The artist's quest was a basic theme in nineteenth-century America. As explorers and adventurers, artists took on journeys of heroic proportion that often equaled the mythic dimensions of the scenes they were intending to record. "In this displacement of the heroic from the work of art to the persona of the artist," the art historian Barbara Novak has observed, "lay, perhaps, part of the attraction of unexplored territory for American artists" of the generations before Remington and Russell.[10] The difference for

22. Enoch Long, *Carl Wimar in Frontier Dress*, 1857. Photograph, 4 3/4 × 3 3/4 inches. Missouri Historical Society, St. Louis, Mo.

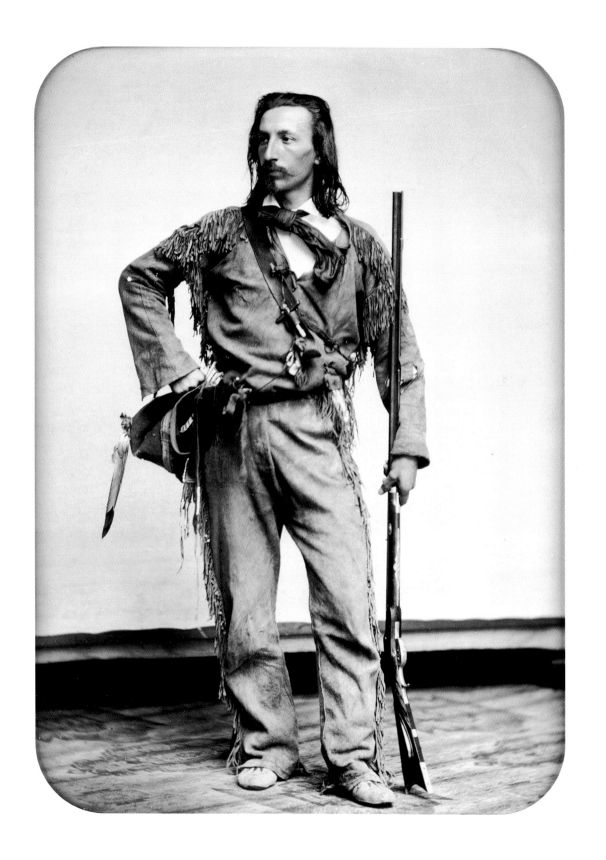

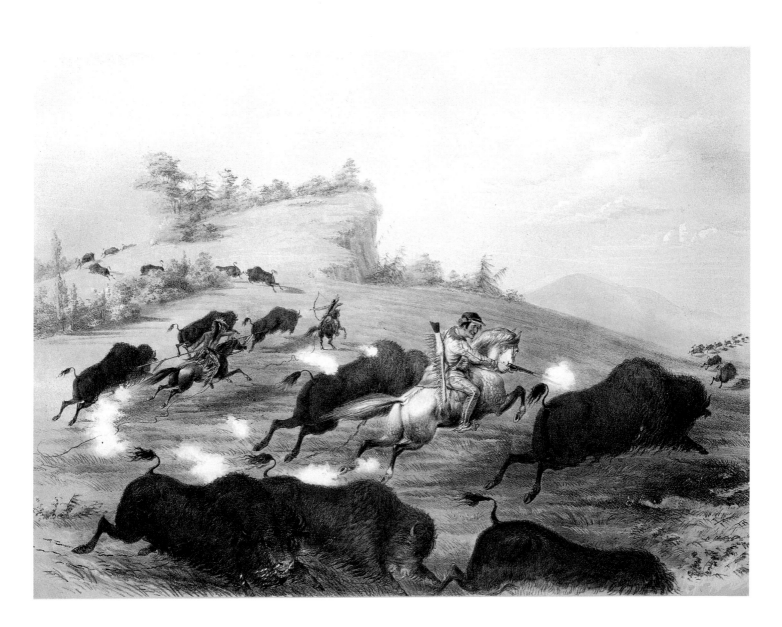

23. George Catlin, *Catlin the Artist Shooting Buffaloes with Colt's Revolving Pistol,* ca. 1851. Tinted lithograph, 25 × 28 inches. Autry Museum of Western Heritage, Los Angeles, Calif.

these two artists was essentially one of sequence: they fixed their identities as heroic figures before bothering to get serious about being artists. Others of their generation, such as Charles Schreyvogel and Henry Farny (1847–1916), followed the more traditional pattern of art training followed by a search for a heroic, or at least a male, identity through a wilderness quest.

That Remington and Russell adopted the role of cowboy early in their public lives exposes a series of paradoxes. Notwithstanding his summer's jaunt to Montana in 1881 and his year of ranching in Kansas in 1883–84, Remington was never a cowboy. Nonetheless, as early as 1889, biographical sketches of him described him as such. By 1894, the year he and Owen Wister were planning their article "The Evolution of the Cow-Puncher" to depict the common drover as a mythic American folk hero, Remington's biographers had cemented his image in place. Alpheus S. Cody, for example, wrote the following misinformed testimonial: "In 1879, he started off to make his fortune ranching in the Far West. An expert horseman, a shrewd and keen observer from the start, he soon rose from a cowboy into a cattleman."[11] Remington never publicly denied Cody's claims, and the fabrication continued to be part of his public image during his lifetime and well beyond.

Russell, who worked on the range for more than a decade in the 1880s and early 1890s, could lay much fairer claim to the title. As early as 1887 Montana newspapers were referring to him as "An Artist under the Guise of a Cowboy."[12] By 1889 he had not only earned the catchy sobriquet of "the cowboy artist" but also created a proper biography to support and enhance it. Russell, claimed one newspaper, "is once more among the scenes of his earlier triumphs. [He] has joined the round-up and will, as of yore, subdue the erratic broncho and chase the nimble and elusive calf."[13] Russell never disclaimed his nickname, but, unlike Remington, he did deny that he had ever been a real cowboy. Although he rode with cowboys, he did not break broncos or rope cattle. He had been a night wrangler and was ever proud to have held even that job with some success.[14]

Both men took full advantage of their association with cowboys, however, and through their art became important contributors to the myth. As the lionization of the cowboy continued into the twentieth century, Remington and Russell maintained their connection with this American icon in the forefront of public attention.

THE MYTHS OF THE WEST

Remington and Russell, as firsthand observers of the western scene and participants on at least a basic level, were granted near-epic standing in the public eye. Russell's eleven years as a "night hawk" on the range and Remington's pursuits as an artist-correspondent in the final phases of the Indian wars—the Geronimo campaign in Arizona in 1886 and 1888 and the tragedy at Wounded Knee, South Dakota, in 1890—provided them with valid credentials as participants in the terminal stages of the western epoch. In their work they collected and presented a full measure of facts and pictorial observations about western life and history as it unfolded in the last two decades of the nineteenth century.

Remington and Russell also helped create and perpetuate the two most pervasive facets of the western myth that evolved in turn-of-the-century America: first, the equating of violence and lawlessness with the concept of masculinity and, second, the attendant although seemingly obverse notion that the West was a Garden of Eden, a bountiful reservoir of resources and natural beauty that was infinitely replenishable.[15] Both Remington and Russell adopted and depicted the cult of masculinity, and Russell was also, to a lesser degree, an advocate of an Edenic West, as depicted in his painting *The Buffalo Herd* (figure 24). Remington's work is so infused with fatalism that the landscape and its riches are ignored, depicted starkly or as a void. His landscape backdrops, in fact, reflected an earlier, pre-Gregg myth that the West was desert, essentially barren of exploitable fruits.

These myths about the West had developed through previous literature and art and had been passed down to Remington and Russell to explore within the context of their own time. Several other myths, to one degree or another, filtered through to these two artists and helped provide a metaphorical framework for their themes. Mid-nineteenth-century artists had created a picture of the West that varnished its history with a number of mythic layers. They presented the frontier, for example, as a redemptive place where communities might be regenerated through the process of pioneering. The doctrine of Manifest Destiny, although complex, suggested among other things that the wilderness, although a dangerous and empty place, could be conquered by the process of civilization. The various forces that might be directed in service to that cause ranged from the

24. Charles M. Russell, *The Buffalo Herd*, ca. 1890.
Oil on board, 17 3/4 × 23 3/4 inches.
Buffalo Bill Historical Center, Cody, Wyo.
Gift of William E. Weiss.

C M Russell

efforts of the common yeoman, represented by the pioneer family of the Oregon Trail, to the forces of current technology, represented by the transcontinental railroad, a technological tour de force. In the public mind the process of civilization was a moral quest, and harnessing the disorder of nature's chaos was construed as a moral and spiritual victory for European Americans, both participants and stay-at-home observers.

Viewed as the promised domain of the common man, the West was also seen as an idyllic place of vast scale. Participants could escape the constraints of society to discover their true liberated selves and thus achieve an epic dimension. The mountain men of the 1830s took on such a presence despite the mundane nature of their labors, just as the cowboy would at the end of the century. Yet while this wilderness was an exotic, otherworldly place, it was destined, as the French philosopher Jean-Jacques Rousseau had surmised about lost paradises a century earlier, to suffer change and ultimately death. The West was predestined to die, and thus the whole era had a tone of finality and fatalism. Pioneering, acculturation, technological advancement, warfare, greed, and a host of other causes sealed its fate—its surpassing attraction leading to inevitable exploitation.[16]

MENTORS FOR TWO MASTERS

As part of the new generation of artists that arose in the 1880s, Remington and Russell extracted heavily from pervasive, established American attitudinal rhetoric, each in his own way, and added a few new twists. They also borrowed freely from artistic conventions of the day, both American and European, in the practice of their craft as painters, illustrators, and sculptors. Their artistic conclusions had much to do with their artistic training, which reflected differences as well as similarities.

Russell was, in his own mind and in his audience's perception, a true child of the West and thus of nature itself. He proudly announced that he was uneducated except in the school of nature, learning his lessons only from Jake Hoover and the cattle trail. Untutored by the academy, he was considered an unspoiled, untainted genius, blessed with innocence and thus free of affectation, pretense, and aesthetic restraint. This frontier prototype goes back to the

25 (opposite top). Charles M. Russell, *Wild Meat for Wild Men,* 1890. Oil on canvas, 20 1/8 × 30 1/8 inches. Amon Carter Museum, Fort Worth, Tex.

26 (opposite bottom). Charles M. Russell, *The Roundup,* ca. 1889. Watercolor, 3 3/4 × 6 3/8 inches. Collection of David P. Bolger and Mark A. Costello, Chicago, Ill.

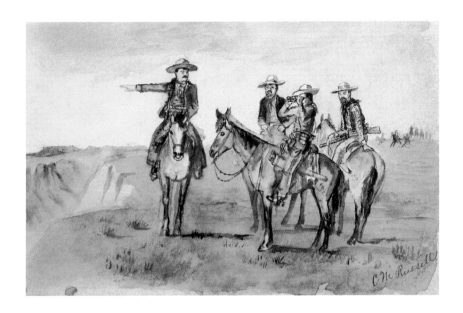

27 (left top). Charles M. Russell, *The Scouting Party,* ca. 1889. Watercolor, 5 × 8 inches. Collection of David P. Bolger and Mark A. Costello, Chicago, Ill.

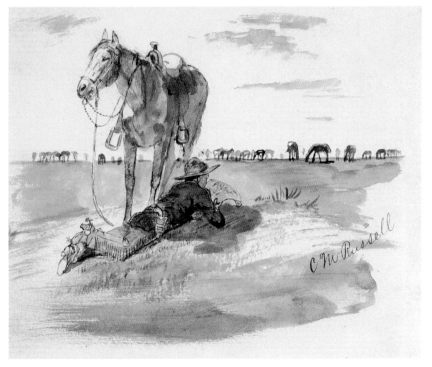

28 (left bottom). Charles M. Russell, *On Watch,* ca. 1889. Watercolor, 5 1/4 × 6 5/8 inches. Collection of David P. Bolger and Mark A. Costello, Chicago, Ill.

29 (opposite). Charles M. Russell. *Ranch Life in the North-West—Broncho Ponies and Their Use—How They Are Trained and Broken,* an engraving from *Leslie's Illustrated News,* May 18, 1889. Wood engraving, 10 1/4 × 14 1/4 inches. Jim Combs Collection, Great Falls, Mont.

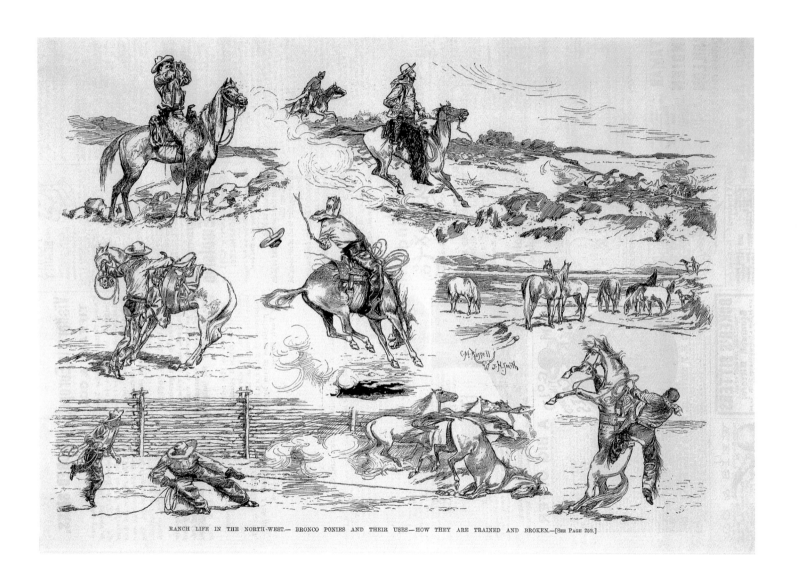

RANCH LIFE IN THE NORTH-WEST.— BRONCO PONIES AND THEIR USES—HOW THEY ARE TRAINED AND BROKEN.—[SEE PAGE 259.]

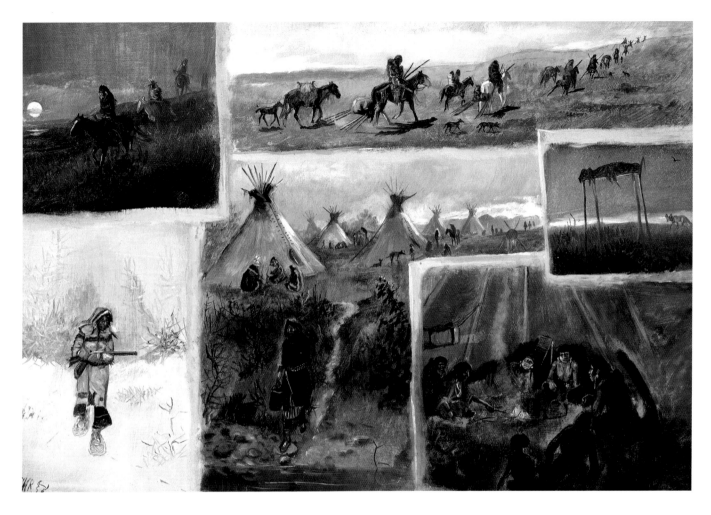

explorer Daniel Boone (1734–1820), who led others into the wilder-
ness, away from the degraded eastern cities and their inherent social
evils. Russell was brushed with the same tint—able, through the
supposedly unsullied truth of his imagery, to reveal the real West and
lead his viewers into it. His pictures of the West, lacking the preten-
sions of artistic sophistication, were more believable than those of
other artists.

Russell's protégé and promoter, Joe DeYong (1894–1975), waxed
hyperbolically about him in 1930: "As for his work, he did more
things well than any other man in America in his field and he did
them first. Everything he did was different from any picture, model,

30. Charles M. Russell, *Western Montage*, ca. 1889.
Oil on canvas, 19¼ × 29⅛ inches.
C. M. Russell Museum, Great Falls, Mont.

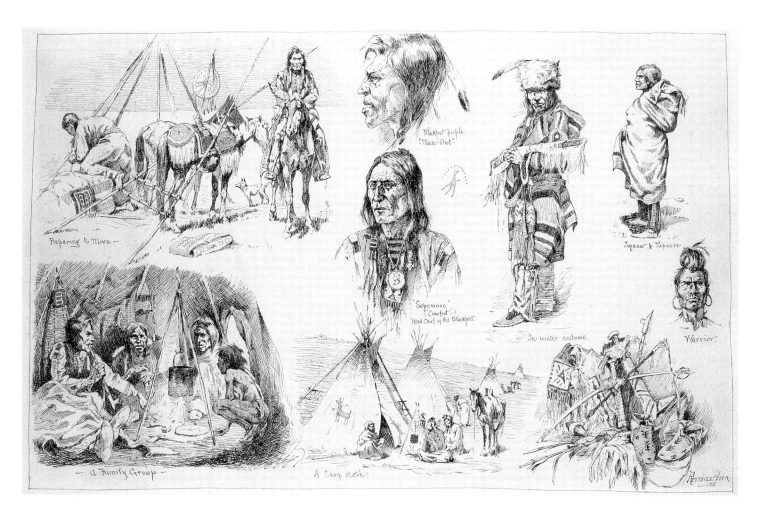

31. Frederic Remington, *In the Lodges of the Blackfeet*, 1887. Pen and ink, 14 1/4 × 22 5/8 inches. Buffalo Bill Historical Center, Cody, Wyo. Gift of Mr. and Mrs. Fletcher Harper.

story or drawing anyone ever saw or heard of and he taught himself everything he ever knew."[17] Although this statement was patently untrue, DeYong and many of Russell's patrons and admirers believed such claims. Yet, despite Russell's refusal over the years to accept European or even domestic academic training, under the pretense or notion that independence of artistic development was somehow more wholesome, more American, and certainly more western, he was strongly influenced by artists here and abroad. The Russell scholar Brian W. Dippie, in his seminal study *Looking at Russell* (1987), first pointed out the debt that Russell's art and vision owed to others.[18]

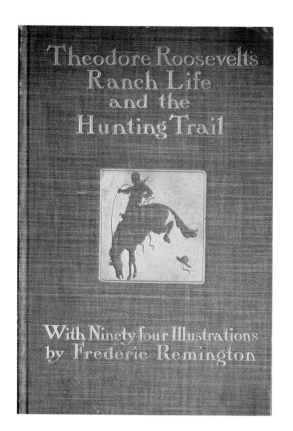

33 (above). Frederic Remington, cover illustration for *Theodore Roosevelt's Ranch Life and the Hunting Trail*, 1901 edition. Book, 10⅝ × 7½ inches. The Western History Collections, University of Oklahoma Libraries, Norman, Okla.

32 (opposite). Frederic Remington, *Our Elk Outfit at the Ford*, 1887–88. Oil on fiberboard, 15 × 23 inches. Diplomatic Reception Rooms, U.S. Department of State, Washington, D.C. Gift of Mr. and Mrs. John A. Hill.

Russell may not have taken lessons in art school, but he did learn much from his exposure to art in popular literature and in public places, especially in St. Louis. Of great importance were the paintings of the German painter Carl Wimar. Although Wimar had lived a generation earlier, his works hung in the Museum of Fine Arts in St. Louis and many other civic buildings in that city. In addition, at the turn of the century, dozens of articles appeared in St. Louis newspapers about Wimar's art and career.[19] Russell was well informed about his predecessor's work and praised it highly. Wimar's paintings were "fine," Russell once wrote to DeYong. "I wish I could paint like he did."[20] And although Russell could never equal Wimar's technical proficiencies, he gleaned much from him, including his fundamental impressions of the artistic expressions of Indians and his Rousseauian notions of the West as an exotic wilderness and a doomed Eden. In addition, he adopted Wimar's principles of composition, based on the formulae of the *tableau* style that Wimar had been taught as a student at the Düsseldorf Academy in the 1850s. From Wimar also came the perception that the buffalo represented the essence of the West and that the buffalo hunt symbolized the region's grandest romantic action and the most profound expression of its demise. Russell's later painting *Wild Meat for Wild Men* (figure 25) reflects this perception.

By 1889, while still working on the range, Russell had developed many of the themes that would characterize his work through the end of the century. These can be seen in a series of nearly two dozen wash drawings that he sent to a Denver friend, William W. Davis, that year. These included images of Indian warriors and Indian and Anglo-European women in Montana, scenes of cowboy life (figures 26, 27, and 28), views of Indian villages, and depictions of wildlife and hunting. The compositions derived from firsthand observations, and many of them, such as that of a bull charging a cowboy and his horse, provided the thematic inspiration for *The Broken Rope* (figure 17) and similar paintings that he produced from time to time in subsequent years. Additional scenes of cowboys at work found their way into print that year, such as *Ranch Life in the North-West—Broncho Ponies and Their Use—How They Are Trained and Broken* (figure 29), and again the compositions seemed to rely on what Russell had seen in his daily work.

Unlike Russell, Remington embarked at an early age on formal

training in art. As a boy he had a penchant for rendering form and action in the margins of his schoolbooks and received encouragement from friends and family to enroll in Yale's new School of Fine Arts. He attended drawing classes there with John H. Niemeyer (1839–1932), who was born in Germany but trained in France. In only three semesters he soaked in the standard Beaux-Arts lessons that would have filtered through Niemeyer from the teachings of French artists such as Jean-Léon Gérome (1824–1904). When his father died, Remington's mother and uncles persuaded him to leave Yale to seek a career in civil service work with the New York state government. That failed to challenge him, and after his various subsequent endeavors in Kansas faltered, he decided on a livelihood as an artist.

Since the drawing classes at Yale were all he had taken, he enlisted the talents of J. Alden Weir (1852–1919), a teacher at New York's Art Students League with whom he studied painting for several months in 1886. Like Niemeyer, Weir had studied under Gérome. Remington's early work was thus basically informed by French academic conventions, including a fundamental respect for superior draftsmanship, a fascination with historical scenes in exotic settings, and a reverence for clear, unsuffused light. At this time Remington is also thought to have rubbed shoulders with the Philadelphia artist Thomas Eakins (1844–1916), and it may have been from Eakins, who was teaching at the Art Students League, that he learned of Eadweard Muybridge (1830–1904) and his photographic experiments with animals in motion.[21]

Those two experiences—a year and a half at Yale and about three months at the Art Students League—constituted the total of Remington's formal training. Most of his contemporaries sought years of fruitful study in Europe, but Remington refused to go. For this unconventional decision he was admired by some. He had "spunk," wrote one friend of his, and the resolve to "kick and fight his way to the front, and will do it without going to Paris or Rome."[22] With respect to training, then, Remington differed from Russell only in degree.

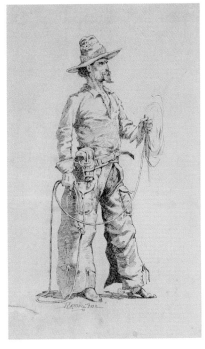

Like Russell, Remington found ready material to inspire him, much of it European in origin, without going abroad to work in some master's atelier. He especially admired a group of French military artists who were famous at the time. The battle paintings of Louis-Ernest Meissonier (1815–91) could be viewed in the galleries of the Metropolitan Museum of Art, and the works of Jean-Baptiste-Edouard

34 (opposite top). Frederic Remington, *Texas Type,* 1888. Pen and ink on card stock, 15 1/16 × 8 3/8 inches. Carnegie Museum of Art, Pittsburgh, Pa. Andrew Carnegie Fund, 1906.

35 (opposite bottom). Frederic Remington, *An Arizona Type,* 1887. Pencil on paper, 11 1/2 × 5 1/4 inches. National Cowboy Hall of Fame and Western Heritage Center, Oklahoma City, Okla.

36 (right). Frederic Remington, *A Bucking Bronco,* 1888. Oil on board en grisaille, 18 × 12 inches. Mr. and Mrs. William P. Healey, Santa Barbara, Calif.

37. Frederic Remington, *A Fight in the Street*, 1888.
Illustration for *Theodore Roosevelt's*
Ranch Life and the Hunting Trail (1888).
Wood engraving, 9⅞ × 11¾ inches.
New York Public Library, New York, N.Y.

Detaille (1848–1912) and Alphonse-Marie de Neuville (1835–85) he
found illustrated in magazines and published portfolios. Early military
studies of U.S. and Mexican soldiers owe much to de Neuville's por-
traits of soldiers from the Franco-Prussian War. Remington's taste for
battle scenes, inspired by these three Frenchmen, achieved a deeper
poignancy and pathos through the influence of Vasili Vereshchagin
(1842–1904), a popular Russian painter who exhibited his work in New
York in the late 1880s. Closer to home, some of the Civil War scenes
of Winslow Homer (1836–1910) also provided compositional and the-
matic guidance to Remington during his formative years, as did pop-
ular prints of historical western episodes such as the ubiquitous
images of Custer's last stand.[23]

Remington's own compositions and themes provided some direction
for Russell, particularly when he attempted more finished paintings. A
case in point is his *Western Montage* (figure 30), a composite view of
Plains Indian life painted about 1889. In layout and narrative it follows
closely Remington's drawing *In the Lodges of the Blackfeet* (figure 31),
done in 1887 and printed in *Harper's Weekly* that year. The view of
the family inside a tepee, the camp scene, the full-length portrait of a
man cradling a rifle in his arms, and the vignette of Indians moving

38. Charles M. Russell, *"So Without Any Ondue Recitation, I Pulls My Guns and Cuts Down on Them There Tin-Horns,"* 1899. Illustration for Wallace D. Coburn's *Rhymes from a Round-up Camp* (1899). Photomechanical reproduction, 5¼ × 6⅞ inches. Buffalo Bill Historical Center, Cody, Wyo.

camp—all were inspired by Remington's earlier portrayal. As Dippie has stated in connection with similarly influenced works, Remington's examples "helped Russell to organize some ideas, select some subjects, compose some paintings, and pose some figures." And such examples exerted influence at the "most impressionable stage of his artistic development."[24] *Western Montage* was to be included in Russell's first published collection of paintings, *Studies of Western Life*, so he wanted to be certain that the design held up to public scrutiny.[25]

Russell also adapted many subjects from Remington's illustrations for Theodore Roosevelt's book *Ranch Life and the Hunting Trail* (figure 33), first published in 1888.[26] This commission had produced some of Remington's strongest, most dramatic early works—including, for example, *A Bucking Bronco* (figure 36), which in some of the book's editions was used for the cover. Poring over its pages, Russell drew thematic ideas for his own works from such picturesque subjects as mustangs defending their young from attacking wolves; various western types, depicted in *Texas Type* (figure 34) and *An Arizona Type* (figure 35); Indians in snowstorms; and ruffians making a dude dance. A particularly dramatic subject, one that would

find its way back into both artists' work in coming years, was the shoot-out in front of the town saloon. Remington's version, *A Fight in the Street* (figure 37), shows the action as it is about to unfold. For him, portent was the most important narrative device, establishing pictorial tension through viewer anticipation and speculation. In Russell's version that appeared a decade later, *"So Without Any Ondue Recitation, I Pulls My Guns and Cuts Down on Them There Tin-Horns"* (figure 38), the figures are presented in a more naturalistic way, and the action is completed or nearly complete.

Even in Russell's later work, when he became far more self-reliant and inventive, he would from time to time turn back to Remington for ideas. The syndicated series of drawings known as *Back Trailing on the Old Frontier,* which Russell developed with the Montana Newspaper Association in the early 1920s, has much in common conceptually with a ten-month series of paintings Remington produced for *Collier's* in 1905 and 1906 under the collective title *The Great*

39. Charles M. Russell, *Radisson on the Lakes,* ca. 1922. Pen and ink and graphite on paper, 14¼ × 23 inches. Amon Carter Museum, Fort Worth, Tex.

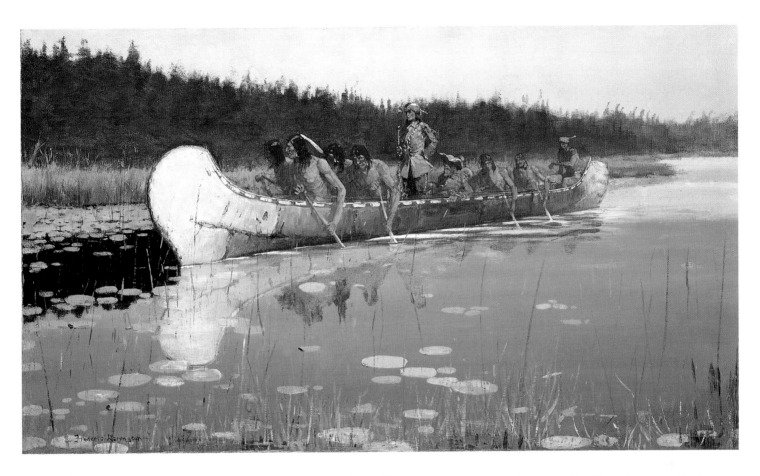

40. Frederic Remington, *Radisson and Groseilliers*, 1905. Oil on canvas, 17¼ × 30 inches. Buffalo Bill Historical Center, Cody, Wyo. Gift of Mrs. Karl Frank.

Explorers.[27] One piece in particular from the Russell group, *Radisson on the Lakes* (figure 39), drawn around 1922, drew its inspiration compositionally from the *Collier's* reproduction of Remington's remarkable painting *Radisson and Groseilliers* (figure 40), painted in 1905. Ironically, *The Great Explorers* group, with the exception of the latter painting, was among those works Remington destroyed in late 1908 after reading the Emerson Hough article.

Russell also learned a great deal from his exposure to the New York illustrator John Marchand and his associates. As a result of those several months in New York in 1904 and subsequent visits for many years thereafter, Russell's palette lightened considerably, his drawing improved, and he began to add gouache to his watercolor pieces, greatly increasing their effectiveness. Late in the decade 1910–20 Russell met Maxfield Parrish (1870–1966). He was impressed by Parrish's "bright colors" and incorporated those intense and brilliant hues into his later paintings with much success.[28]

41 (left). Rufus F. Zogbaum, *Painting the Town Red,*
1886. Wood engraving, 28 × 18 inches.
From the Collections of Tom Ryan, Midland, Tex.

SHARED INSPIRATION

Remington and Russell probably even shared the same sources of
some models for their early works. Rufus F. Zogbaum (1849–1925), an
illustrator for *Harper's Weekly* in the mid-1880s, portrayed the theme
of cowboys shooting up the town in one of the magazine's fall 1886
issues.[29] Zogbaum's wood engraving *Painting the Town Red* (figure 41)
depicted cowboys as rowdies bent on having a galloping good time.
Their roughhousing played as mildly amusing to the townsfolk,
although not to the Chinese man, the butt of a racist practical joke.
Three years later *Harper's Weekly* published Remington's version of
the scene under the title *Cow-boys Coming to Town for Christmas*.[30]
Here the theme is the same but developed more dramatically, the
cowboys and their mounts having taken on more epic proportions
than in Zogbaum's work. In the 1890s Russell too adopted the subject
in several works including *Whooping It Up (A Quiet Day in Chinook)*
(figure 42). For him the frightened Chinese man, although an unfor-
tunate victim, was a vital ingredient in developing the full potential of
ethnocentric albeit essentially playful humor of such dusty Main
Street dramas.

 For many of the variations of his favorite subject—the buffalo
hunt—Russell based his designs on Carl Wimar's compositions.[31] But
both Remington and Russell relied on another American painter,

42 (opposite). Charles M. Russell, *Whooping It Up*
(A Quiet Day in Chinook), ca. 1895.
Watercolor, 19 3/4 × 28 3/4 inches.
California State Parks—Will Rogers
State Historic Park, Pacific Palisades, Calif.

43. Charles M. Russell, *The Stand.*
Crossing the Missouri, ca. 1889. Oil on canvas,
20⅛ × 30⅛ inches. Amon Carter Museum,
Fort Worth, Tex.

Albert Bierstadt, for their gorier interpretations. Both *The Buffalo Hunt* (figure 45), by Remington, and several versions of related works by Russell stem from *The Last of the Buffalo,* the profoundly fatalistic salon piece that Bierstadt framed and sent to Paris in 1889. Prints of this painting were issued in the early 1890s (figure 44) and could easily have been seen by Remington and Russell. By showing the Indian and the horse trampled by the enraged buffalo, Remington and Russell added a realistic touch to the wrenching allegory, but they all implied essentially the same thing: the West in its pure, unspoiled state, symbolized by the buffalo and the Indian, was dying.

Some modern observers have contended that the wrong parties were blamed for that demise and that the victims were portrayed in Bierstadt's panoramic drama as the perpetrators.[32] More likely, however, all three painters were simply acknowledging the mutual struggle and suffering of both the Indian and the buffalo. Russell had by this time already painted and published a work that clearly placed the blame for the bison's near extinction on the Anglo-European buffalo hunters. Entitled *The Stand. Crossing the Missouri* (figure 43), it appeared in print in 1890 as a plate in his *Studies of Western Life.* The accompanying commentary, supplied by Russell's friend Grandville Stuart, made an even stronger accusation: the tragedy was the result of "a mad race between white hunters, half breeds, and Indians as to who should secure the most hides and tongues" in the decade 1873–83 and the fact that "our government stood supinely by and raised no hand to stay the horrid butchery."[33] Remington too showed white hunters at work in the sad episode of the bison slaughter. His illustrations for Theodore Roosevelt's article "Buffalo Hunting," which appeared in 1889, demonstrate that he, like Russell, was endeavoring to hide neither the shame nor the reality of the slaughter, as in *Splitting the Herd* (figure 46).

Life-and-death contests between men and animals served not only as emblems of the passing frontier but also as metaphors for manhood. Remington's fascination with the activities of the bullring during a trip to Mexico in 1889 resulted in an important early painting that, in its conceptual construction, was not far removed from *The Buffalo Hunt.* However, it spoke more specifically of Remington's search for a grand testament to man's control over nature. Entitled *Bull Fight in Mexico* (figure 47), the painting was a rather matter-of-fact treatment of the violent incident, as if the artist were reporting on a sports event

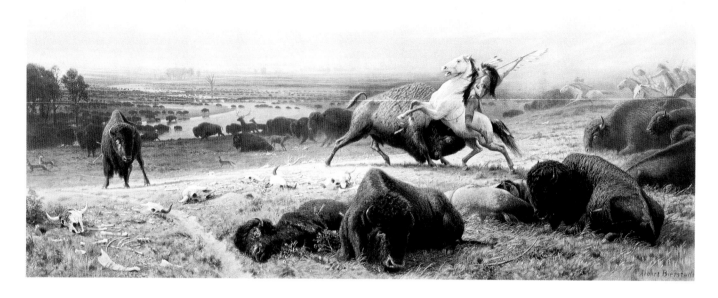

rather than a display of carnage. In contrast, a bullfight depicted a generation earlier by Edouard Manet (1832–83) was so bloody that it had to be substantially altered because of negative reaction from French audiences.[34] For Americans, Remington's bullfight was apparently more acceptable fare, and *Harper's Weekly* printed it across two pages in its June 1, 1889, issue.

Russell, who witnessed a bullfight in 1906, found it repugnant and refused ever to attend another, whereas Remington enjoyed repeat performances in later years. Nonetheless, Russell continued the theme of macho, near-death incidents in many of his cowboy paintings. Although a bullfight is ritualized killing and a life-threatening scrap with a wild steer is a hazard of cowboy life, in both the potentially grisly outcome lends itself to pictorial effect and public appeal. Russell explored the theme in the 1890s and early 1900s in such works as *The Broken Rope* (figure 17) and later in *Where the Best of Riders Quit* (figure 49).

44 (above). Albert Bierstadt, *The Last of the Buffalo (Buffalo Hunt)*, 1891. Etching on chine collé, 16 × 27¼ inches. National Museum of Wildlife Art, Jackson Hole, Wyo.

45 (opposite). Frederic Remington, *The Buffalo Hunt*, 1890. Oil on canvas, 34 × 49 inches. Buffalo Bill Historical Center, Cody, Wyo. Gift of William E. Weiss.

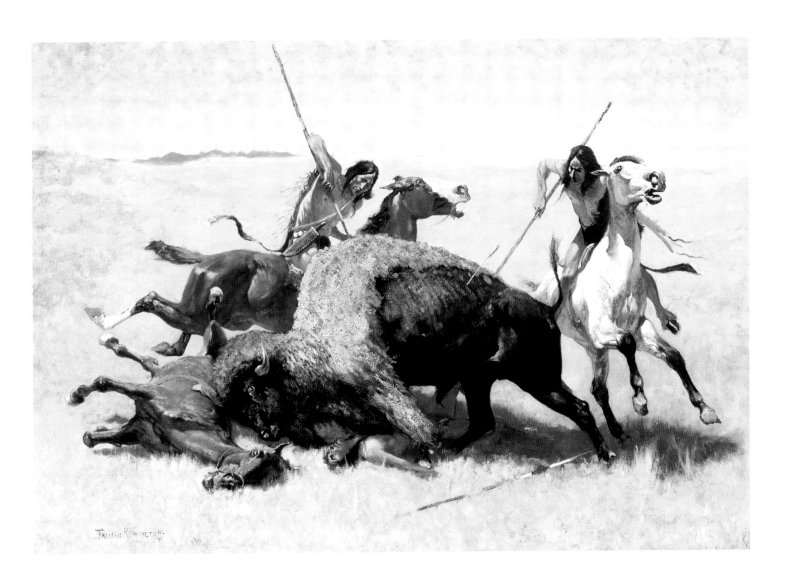

46 (left). Frederic Remington, *Splitting the Herd*, 1889. Ink and gouache on paper en grisaille, 18 × 25 ¼ inches. The Rockwell Museum of Western Art, Corning, N.Y.

These scenes recall Theodore Roosevelt's dicta that the vigorous life is the healthy life and that the cult of masculinity depends on challenging oneself, even putting oneself in danger.

Roosevelt's impact on both artists was significant. All three men shared similar youthful experiences, escaping a comfortable but lackluster adolescence to prove their manhood and seek self-identity in the West. Remington had personally known Roosevelt since the late 1880s and was even occasionally invited to White House dinners, whereas Russell's connection was only indirect (Roosevelt owned one of Russell's works). Both artists, however, reaped a substantial harvest from Roosevelt's literary endeavors. As noted earlier, Remington was commissioned in late 1887 to illustrate *Theodore Roosevelt's Ranch Life and the Hunting Trail*, vignettes of the history of the West and of western life. Remington had first crack at pictorializing Roosevelt's stories and themes, but Russell followed closely. Many subjects that would fill Remington's and Russell's canvases in future years grew out of this book.

One example of this interlinking is the dramatic account of cowboys fighting for their lives against huge odds. Roosevelt's story went like this:

47 (opposite). Frederic Remington, *Bull Fight in Mexico*, 1889. Oil on canvas, 24 × 32 inches. Santa Barbara Museum of Art, Santa Barbara, Calif. Gift of Mrs. Sterling Morton to the Preston Morton Collection.

A few cool, resolute whites, well armed, can generally beat back a much larger number of Indians if attacked in the open. One of the first cattle outfits that came to the Powder River country, at the very end of the last war with the Sioux

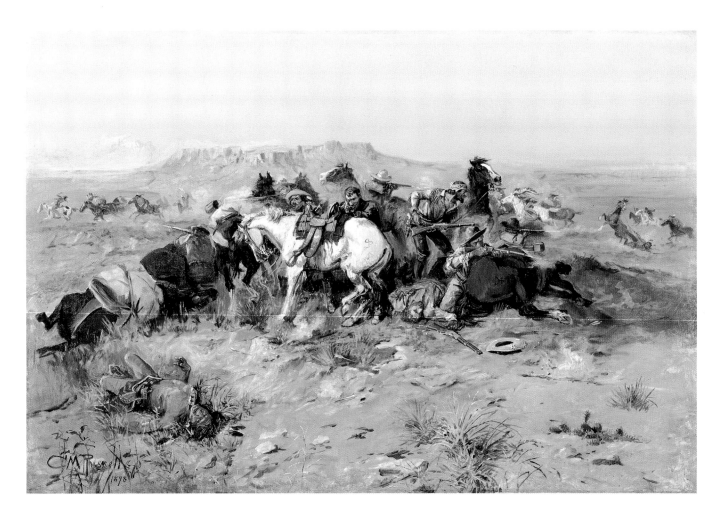

and Cheyenne, had an experience of this sort. There were six or eight whites, including the foreman, who was part owner, and they had about a thousand head of cattle. These they intended to hold just out of the dangerous district until the end of the war, which was evidently close at hand. They would thus get first choice of the new grazing grounds. But they ventured a little too far, and one day while on the trail, were suddenly charged by fifty or sixty Indians. The cattle were scattered in every direction, and many of them slain in wantonness, though most were subsequently recovered. All the loose horses were driven off. But the men themselves instantly ran together and formed a ring, fighting from behind the pack and saddle ponies. One of their number was killed, as well as two or three of the animals composing their living breastwork; but being good riflemen, they drove off their foes. The latter did not charge them directly, but circled round, each rider concealed on the outside of his horse; and though their firing was very rapid, it was, naturally, very wild. The whites killed a good many

48 (above). Charles M. Russell, *A Desperate Stand*, 1898. Oil on canvas, 24 1/8 × 36 1/8 inches. Amon Carter Museum, Fort Worth, Tex.

49 (opposite). Charles M. Russell, *Where the Best of Riders Quit*, ca. 1920. Bronze, 14 1/2 × 10 3/4 × 7 1/2 inches. Spencer Museum of Art, The University of Kansas, Lawrence, Kans. Anonymous gift in memory of Mr. and Mrs. W. P. Innes and Mr. and Mrs. L. E. Phillips.

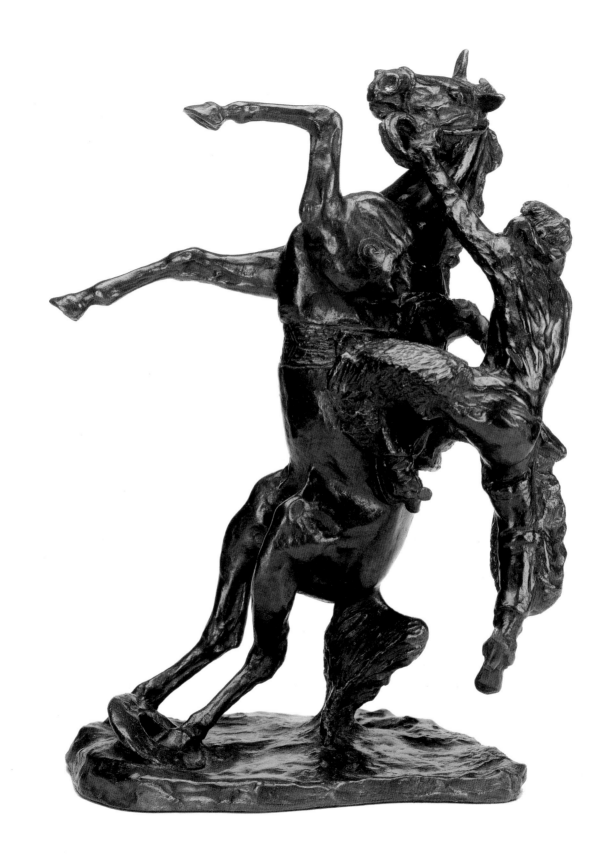

50. Frederic Remington, *An Incident in the Opening of a Cattle Country*, 1887. Oil on canvas en grisaille, 17 $^3/_8$ × 24 $^7/_8$ inches. Autry Museum of Western Heritage, Los Angeles, Calif.

ponies, and got one scalp, belonging to a young Sioux brave who dashed up too close, and whose body in consequence could not be carried off by his comrades, as happened to the two or three others who were seen to fall.[35]

Remington's response to that passage was a brutally frank painting he titled *An Incident in the Opening of a Cattle Country* (figure 50). It became the standard pictorial formula on which he would build numerous mythic variations on the theme of survival on the plains. Later versions might replace cowboys with soldiers or mountain men, but the construct remained the same. One, *The Last Lull in the Fight (The Last Stand)* (figure 51), painted in 1903, extended Roosevelt's message into the new century. Typically viewed as hopeless last stands—in the circular composition the rifles extend outward, resembling hands on a clock and implying that time is ticking out for the frontiersman—these are really metaphysical salvos celebrating the earlier opening of the West. In the Roosevelt episode all but one of the cowboys survive the ordeal and, presumably, go on to open the range beyond for their purposes. In *The Last Lull in the Fight,* the horizon is expansive, suggesting that despite this initial, soon-to-be-fatal encounter, the range will ultimately be available for white incursion and exploitation.

51. Frederic Remington, *The Last Lull
in the Fight (The Last Stand)*, 1903. Oil on canvas,
30 × 60 inches. The Richard and Jane Manoogian
Foundation, Taylor, Mich. Private collection.

Russell knew much about this process of the opening of the range. He had been a part of the cattle business for eleven years, from 1881 to 1892, moving from one range to another with various outfits as the industry expanded and experiencing the uncertainties of weather and competition from farmers, especially sheep farmers. *A Desperate Stand* (figure 48), one of his many versions of the theme, suggests much the same outcome as *The Last Lull in the Fight*. These cowboys are hunkered down in the face of seemingly very large odds. The parched sands in the foreground, as in Remington's interpretation, and the mountains behind are little more inviting than the Indian adversaries. Russell's pictorial transcription of Roosevelt's story is no less true to its source, including even the warrior who got too close. Moreover, he relied on the basic composition that Remington had supplied in his *Ranch Life* illustration.

On occasion the influence possibly went the other way, when Remington may have learned from Russell and adapted imagery and ideas for paintings from his Montana compatriot. A case in point is Russell's set of drawings *Initiation of a Tenderfoot* (figure 52) and *Initiated* (figure 53), both of which appeared as illustrations in his second book, *Pen Sketches* (1899). Although it was published in Great

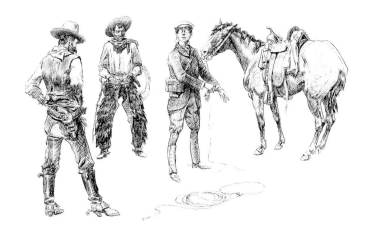

52. Charles M. Russell, *Initiation of a Tenderfoot*, ca. 1899. Pen and ink on paper, 14 × 18 inches. The Rockwell Museum of Western Art, Corning, N.Y.

Falls and not found in Remington's library, it is possible that Remington could have seen a copy. Sometime after 1900, probably around 1905, Remington painted his canvas known as *Buying Polo Ponies in the West* (figure 55). The painting was not published until 1910, and the title was perhaps not entirely apt. The gesture of the cowboy at the center of the composition has several possible interpretations: a take-it-or-leave-it signal to a prospective buyer or an invitation for the unsuspecting eastern gentleman to take a ride, most likely one he will regret, as suggested in Remington's bronze *Outlaw* (figure 54), done in 1906. The jaunty poses of the two cowboys, their juxtaposition to each other, and the horse's weariness, its ears laid back, would suggest inspiration by Russell's *Initiation of a Tenderfoot*, although Remington's barnyard face-off, while potentially explosive, is understated.

The most obvious difference between the two interpretations of this trick-the-dude story is that Russell felt compelled to finish the tale pictorially while Remington was content to establish the setting for potential action and leave the rest to the viewer's imagination. Russell often produced pictorial work in pairs—"before" and "after" sequences—that fit well with his penchant for storytelling and humorous anecdote.

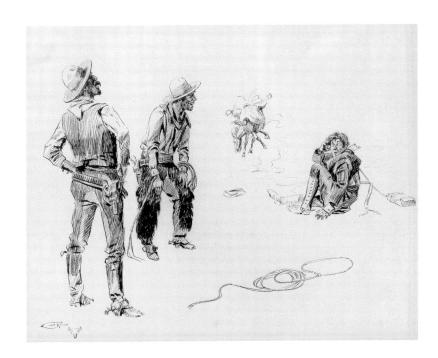

53. Charles M. Russell, *Initiated,* ca. 1899.
Pen and ink on paper, 10¼ × 13 inches.
Private collection.

He could not tell a joke without a punch line, and the resulting hilarity is written all over the cowboys' faces in both frames of the episode. Because Remington's primary concern was with portent, he was satisfied—and probably felt his product to be somewhat more sophisticated—to set up a foreboding situation without being obvious about its conclusion. These differing forms of narrative are primarily a function of style, but both work equally well.

One other comparison that might be considered revolves around the character in the scene with which each artist might have identified. Russell obviously would have sided with the cowboy pranksters, while Remington might have gone either way. This reveals a significant contrast in their individual and artistic self-images. According to the western art aficionado George Schriever in his revealing comparison of the two artists, Russell's image was that of a "carefree, easy-going, droll, diamond-in-the-rough cowboy," while Remington was truer to his roots and "played it straight. He was and remained an Easterner who loved the West and spent as much time as he could there."[36] Many an outside observer in the artists' lifetimes allied Russell with a rough and innocent West and Remington with an effete and despoiled East, and to some degree the artists themselves would have concurred.

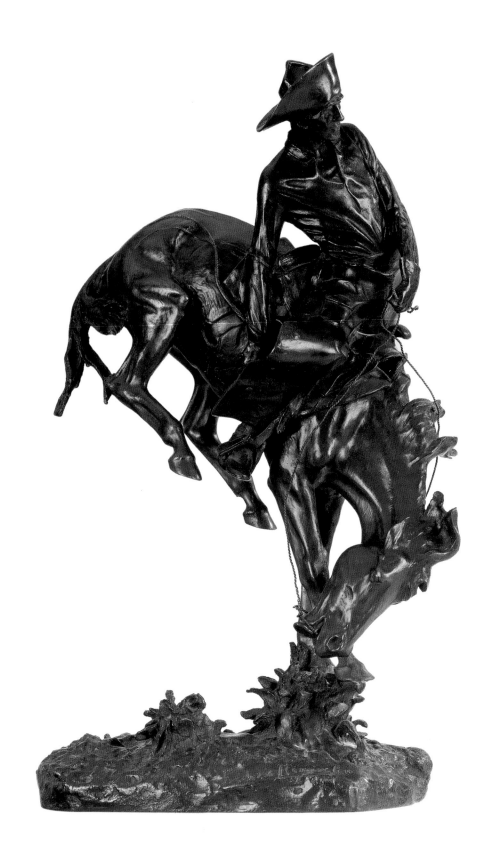

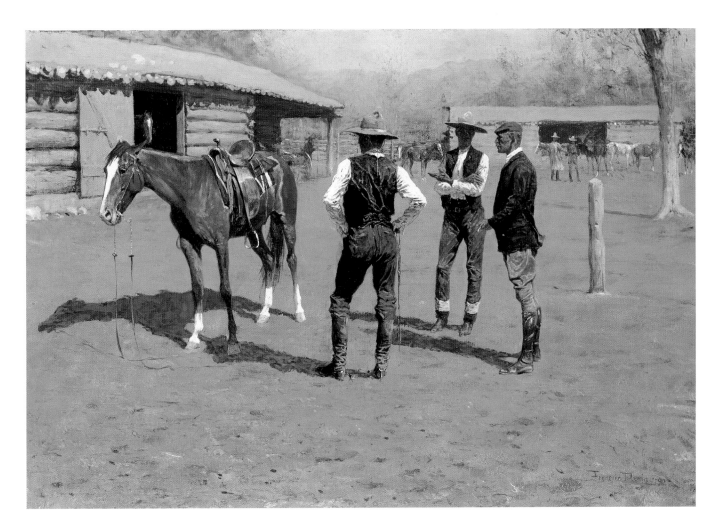

55 (above). Frederic Remington,
Buying Polo Ponies in the West, ca. 1905.
Oil on canvas, 27 × 40 inches.
The Detroit Athletic Club, Detroit, Mich.

54 (opposite). Frederic Remington, *Outlaw,* 1906
(Roman Bronze Works, no. 15).
Bronze, 22 3/4 × 15 × 12 inches. John L. Wehle
Gallery of Sporting Art, Genesee Country Village
and Museum, Mumford, N.Y.

The comparison played into their hands. Russell's celebrity was based on the unspoiled, frontier genius tag, and without question his heart and spirit were of the West. Besides, for many years, his market was essentially regional. "There's nothing in the East for me," he wrote in 1901, a few years before he began selling his works on both coasts. "What do eastern people care about my pictures? Why, they wouldn't give thirty cents a dozen for them. It's the Western people who understand and want my pictures."[37] Remington, on the other hand, sought identity as an illustrator for eastern magazines and audiences and as an academic artist whose work would be appreciated and marketable nationally but credentialed in the East. Russell's expectations of the East, when he later learned that his works were prized there, were simply that of a marketplace. Remington's required critical recognition as well.

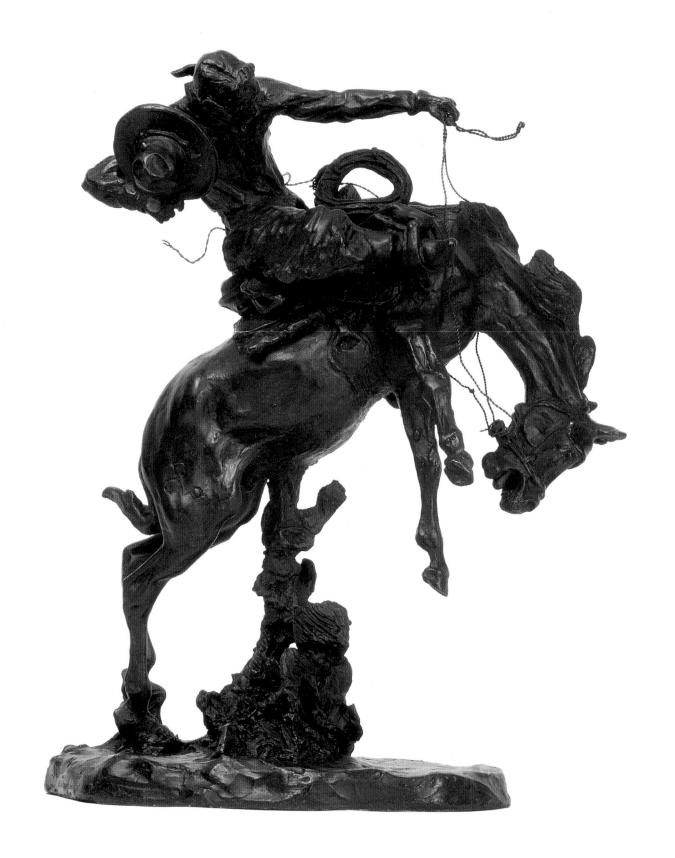

57 (above). Frederic Remington, *I Settle My Own Scores*, 1891. Watercolor, 15 × 8½ inches. Arthur J. Phelan, Chevy Chase, Md.

56 (opposite). Charles M. Russell, *A Bronc Twister*, 1920. Bronze, 18 × 12½ × 8¼ inches. Montana Historical Society, Helena, Mont. Gift of Eugene E. Wilson in memory of Eugene Talmadge Wilson.

PERCEPTIONS OF THEMSELVES AND THE WEST

In siding with the cowboys in his pictures, Russell showed more broadly that he identified with the common man in his art and in his artist persona. He viewed himself as an ordinary person somehow blessed with extraordinary skills. He cherished his place among America's working classes, and when he depicted himself in his genre work, as he occasionally did, it was generally as a quiet bystander, observing quotidian events and human foibles from just outside the direct circle of activity. He was one of the least sententious men of his era in judging the character of others, and he was open about his own flaws. Just before he died he wrote: "I have many friends among cow-men and cowpunchers. I have always been what is called a good mixer—I had friends when I had nothing else. My friends were not always within the law, but I haven't said how law-abiding I was myself. I haven't been too bad nor too good to get along with."[38]

The common people of the West were not only Russell's friends. They also proved to be his most compassionate, empathetic judges and enthusiastic patrons. "The severest critics of pictures of western life," wrote one Montana newspaper in 1921, "are the type of men who are portrayed and these are the men who praise most highly the truth, not only of detail but of the theme, of every story Russell tells in colors."[39]

The same article lent perspective on Remington as well. One charge that had been leveled against Remington's work—a charge that seemed "well warranted" to many westerners—was that "Remington caricatured his western characters." The argument went that Remington was not close enough to the people he painted to provide a genuine portrait. He was also perceived as making his characters larger than life. In Russell's world it took "regular men" to handle what western life dished out, like the cowboy in *A Bronc Twister* (figure 56), while in Remington's world only "men with the bark on" could survive,[40] men like the sheriff in *I Settle My Own Scores* (figure 57). "His Indians, cowboys, ponies and cattle were all exaggerated" rather than "faithfully" rendered types.[41]

These were more than regional observations. They also related to Remington the man. Unlike Russell, Remington never saw himself as ordinary, either as an artist or as a man. His aspirations were to be at the absolute top of his field, and his ego matched his formidable girth; he identified with epic men serving epic causes. As an artist-

correspondent he himself served with the military first during the Indian wars and later on the front lines in Arizona, South Dakota, and Cuba. As a painter and sculptor of cowboys and Indians, mountain men and soldiers, he looked for heroic actions and characters resolute against formidable odds with whom to identify. And in his later paintings and bronzes he chose to depict broad segments of the West not as a remote, mundane region but as an epic and historically transforming process that mirrored Theodore Roosevelt's 1889 monumental multivolume treatise *The Winning of the West*. "History invites him to celebrate dramatic themes," observed the critic Royal Cortissoz in 1910.[42] Remington saw himself as a part of that history.

Some students of Remington have made him out to be, as Russell in fact was, a champion of the nameless "little man" in American history.[43] Yet while he did not ignore the average man, it was the larger-than-life figure that consumed his energies. Remington was a fatalist at heart, and "the gallant hero in jeopardy, whether trooper, cowboy or Indian, was [his] forte."[44] In his celebration of the fatal conflict and the epic encounter in the West, Remington tended to ignore and obviate the common humanity of the scene. By contrast and by virtue of

58 (above). Charles M. Russell, *Charles M. Russell and His Friends*, 1922. Oil on canvas, 43 × 81 inches. Montana Historical Society, Helena, Mont. Mackay Collection.

59 (opposite). Frederic Remington, *Self-Portrait on a Horse*, ca. 1890. Oil on canvas, 29 1/4 × 19 1/2 inches. Sid W. Richardson Collection of Western Art, Fort Worth, Tex.

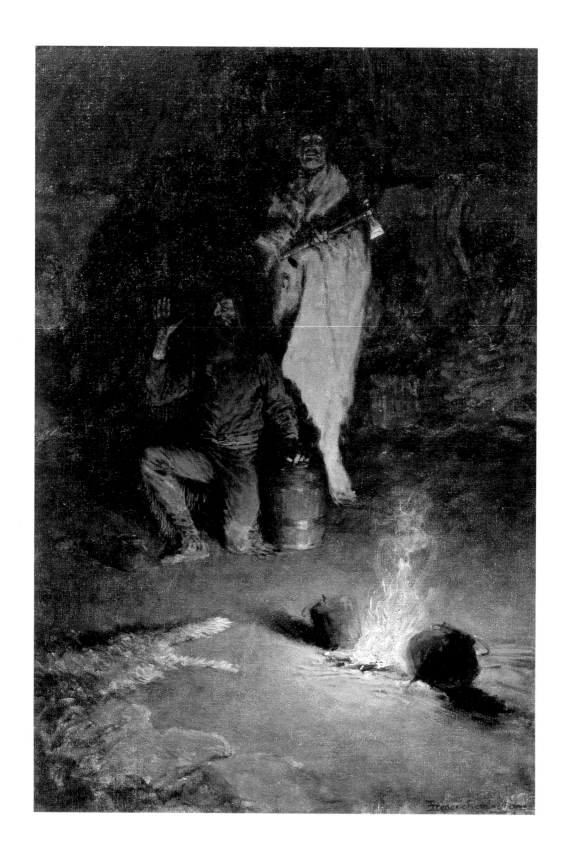

Here's how to me and my friends the same to you and Yours

I savvy these folks

61 (right). Charles M. Russell, *I Savvy These Folks,* 1907. Photomechanically printed postcard by Ridgley Calendar Company, Great Falls, Mont., 3⅝ × 5½ inches. Joe Crosby, Oklahoma City, Okla.

his own experience and personality, Russell seemed to gravitate toward a more sympathetic rendering.

While Remington's vision of the West was linear, Russell's was concentric and fundamentally inclusive. For him the region and its people functioned as the focal essence of history, and their daily interactions served as cardinal elements in the story he chose to tell. His was a fairly heterogeneous social landscape in which the players of many races and social classes shared the limelight, as seen in *I Savvy These Folks* (figure 61). Ethnic diversity played a relatively wide-ranging role, at least for the times, in Russell's narrative. His art came much closer to reflecting what the historian Patricia Limerick has called the "rendezvous model" of western history than did Remington's. He provided an image of the West as a "great meeting ground," a polyglot "multi-sided convergence of people."[45]

Remington's West was more allied to what Limerick calls the "frontier model," in which "the stars of the story were northern European and white Americans" who forced their way across the continent by dint of actual and imagined superiority of technology, will, and moral fiber.[46] This is a linear rather than a circular pattern of human history, in which people acted on and against others, as opposed to living in concert with them.

Russell often pictured himself as an interlocutor figure, looking out at his audience but gesturing over his shoulder into the past. Like Charles Willson Peale's famous self-portrait, *The Artist in His Museum* (1822), in which the painter invites the viewer into his galleries of

60 (opposite). Frederic Remington, *Guard of the Whiskey Trader,* 1906. Oil on canvas, 30¾ × 21¼ inches. The University of Arizona Museum of Art, Tucson, Ariz. Gift of Mr. and Mrs. Samuel L. Kingan.

enlightenment, many of Russell's self-portraits—for example, *Charles M. Russell and His Friends* (figure 58)—picture the artist welcoming his audience into his world. Russell intended for the West to be accessible, and he wanted the characters in the vast play he directed to be spotlighted and brimming with life. His paintings were stages set for brilliant western performances by people he had known or wished he had.

Remington the artist was not so evident in his work. He could be found behind the scenes for the most part, except in a few illustrations where he posed himself as a rough and vigorous participant in a sporting or hunting episode. In his only known, fully developed self-portrait (figure 59), Remington sits astride a white horse with a rifle across his saddle, blocking a path up a rocky hill behind him. His stare is fixed on the viewer with an expression that, if not defiant, is not convivial. He wants to be sure that his viewers understand his West to be a formidable place, a barren and sun-scorched piece of earth accessible only to his "men with the bark on." His eastern audiences, not particularly interested in testing their mettle by venturing past him to the indistinct trail beyond, would be satisfied to experience the West vicariously through his pictures and stories.

Remington's West not only appeared physically inhospitable but also was shrouded in mystery and peril. Many of his later paintings in particular, such as *Guard of the Whiskey Trader* (figure 60), speak to a formidable, forbidden, shadowy quarter that would test the will of even the most resolute. Such was Remington's fearsome place, where horses and riders bridled at unfathomable sounds and fallen trees impeded the path in a dark and unforgiving landscape.

REMINGTON, RUSSELL, AND WOMEN

In Remington's and Russell's art, the matter of accessibility involved not only physical and psychological impediments but also larger social issues. With Remington, for example, the West was a gender-specific domain. Men of a certain resolute nature might survive, but it was definitely no place for a woman. So focused was he on that exclusive theme that he denied women a place in the West as well as in his art. He often commented that he could not paint women, and, when required to do so for an illustration assignment, the results were

62 (above). Frederic Remington,
Letter to Eva Remington, November 6, 1900.
Pen and ink on paper, 9 1/2 × 6 inches.
Owen D. Young Library, Canton, N.Y.
Frederic Remington Collection, Special
Collections, St. Lawrence University Libraries.

63 (opposite). Frederic Remington, *Good Night!
Perhaps I Shall Come To-morrow,* bookplate from
Harper's New Monthly Magazine, May 1895.
Photomechanical reproduction, 3 7/8 × 4 3/4 inches.
Memphis Public Library, Memphis, Tenn.

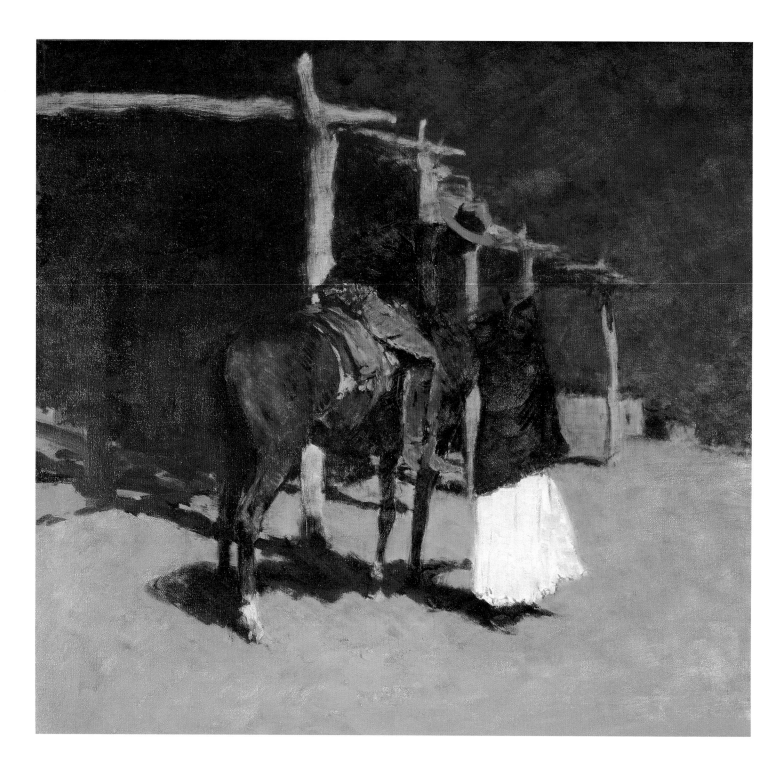

64. Frederic Remington, *Waiting in the Moonlight*, 1907. Oil on canvas, 27 × 30 inches. Frederic Remington Art Museum, Ogdensburg, N.Y.

invariably off the mark. A drawing he produced for Owen Wister's story "La Tineja Bonita," published in the May 1895 issue of *Harper's Monthly*, provides a case in point. One scene in the tale called for Remington to depict a *vaquero* (a Spanish cowboy) coming to court an attractive young woman. He produced the illustration—entitled *Good Night! Perhaps I Shall Come To-morrow* (figure 63) and showing a man on a horse looking down at a scowling damsel—but rather grudgingly. In a letter to Wister in December 1894, he grumbled, "Didn't get the girl 'pretty' as the second word unfortunately says she was—but no one can expect that of me...."[47] To beautify the scene was not, in Remington's mind, part of his charge. Even the introduction of a feminine presence would potentially gentle the macho world that he sought to create. As a consequence, he generally left women out of his art until his later works.

On the surface, *Good Night!* is not dissimilar to a painting produced by Russell in these same years. *Thoroughman's Home on the Range* (figure 65) showed a mounted cowboy leaning from his saddle to speak to a demure young woman. Her stance is coy, in contrast to Remington's Hispanic lady, but she is rather plain and like the Wister heroine is engaged in daily chores in front of a house, which suggests domesticity. Russell's cowboy is more relaxed and less formal, although no more sincere than Remington's in his pursuit. A sense of potential belonging to the land, of permanency and bonding, persists in both works. The primary difference then is one of motivation. Russell produced his painting out of affection and respect for the process of domestication. He seemed a willing proponent of the positive values to be found in rooting oneself in a benevolent landscape. He had been married for about a year himself and evidently, as reflected in this and several similar pieces, respected marriage as an institution. Remington rendered his scene of potential connubial happiness only to satisfy a client and even then with a certain amount of fuss. Like Russell, he was happily married and had been since 1884. But that still did not guarantee women much of a place in his West or in his art.

Surprisingly, in the last few years of his life, Remington produced some strikingly beautiful and emotionally engaging western scenes that involved women. These include *The Hungry Moon*, painted in 1906; *The Warrior's Last Ride*, painted in 1907 and later destroyed; and *Waiting in the Moonlight* (figure 64), painted in 1907. The latter

65. Charles M. Russell, *Thoroughman's Home
on the Range,* 1897. Watercolor, 9½ × 15 inches.
C. M. Russell Museum, Great Falls, Mont.

66. Charles M. Russell, *Cowboy Bargaining for an Indian Girl,* 1895. Oil on canvas, 19 1/8 × 28 1/4 inches. Hood Museum of Art, Hanover, N.H. Gift of J. Shirley Austin, Class of 1924.

is a hauntingly romantic nocturne in which shadowy figures interact with the rhythms of light that play along the wood supports of an adobe veranda. The white skirt lighted by the moon excites the eye, but all else is skillfully subdued by the tonal uniformity. Yet in the final analysis the romance is an awkward one, hinting as much at intrigue and adventure as at sentiment. In mood and setting—a dirt street somewhere in the Southwest—*Waiting in the Moonlight* contrasts with Remington's work of an earlier era.

Russell also carried courtship roles one step further, boldly countering the racial strictures of his day. The practice of interracial marriage

67. Charles M. Russell, *Waiting and Mad*, 1899. Oil on canvas, 11⅞ × 17¾ inches. Indianapolis Museum of Art, Indianapolis, Ind. Gift of the Harrison Eiteljorg Gallery of Western Art.

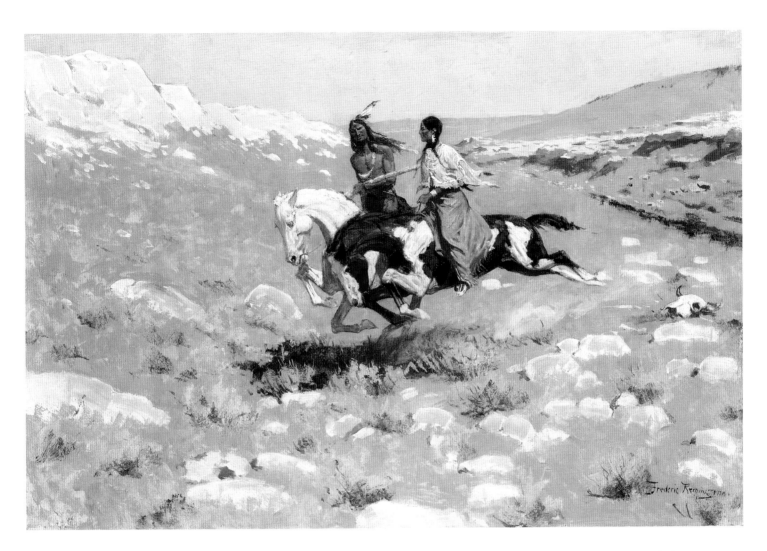

68. Frederic Remington, *Ceremony of the Fastest Horse*, 1905. Oil on canvas en grisaille, 27¼ × 40⅛ inches. The Art Institute of Chicago, Chicago, Ill. George F. Harding Collection.

between Anglo-European men and Indian women, although frequent enough in Russell's world, was rarely the subject of art in his generation. Russell's proposal scene *Cowboy Bargaining for an Indian Girl* (figure 66), was evidence of the artist's fascination with love relationships of all sorts at the time he himself was courting his wife-to-be, Nancy Cooper. The cowboy in the picture has only one horse to trade; it may not be enough to close a deal, for the father appears to be a hard bargainer. The tawny grass on the prairie beyond suggests that it is autumn, however, and perhaps the thought of one less mouth to feed over the winter will help guarantee the match.[48]

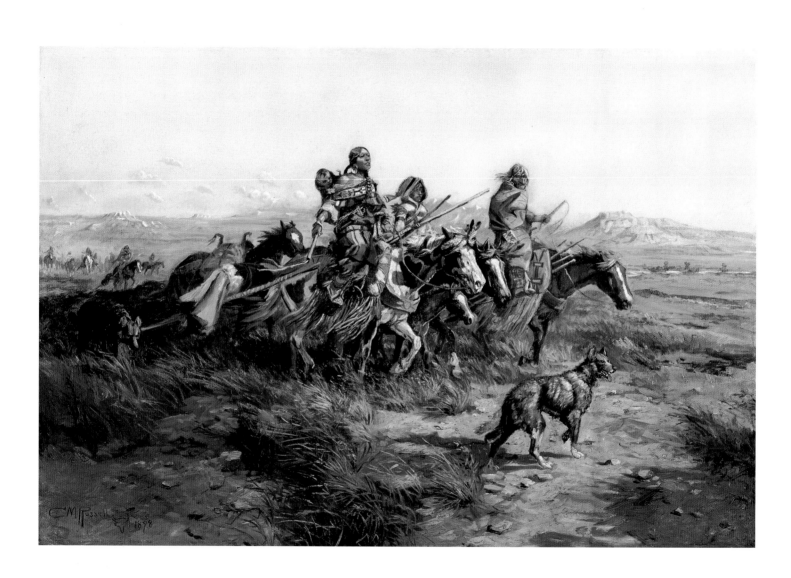

69. Charles M. Russell, *Indian Women Moving*, 1898. Oil on canvas, 24 1/4 × 36 inches. Amon Carter Museum, Fort Worth, Tex.

Russell's ease in incorporating women into his art may come from the fact that he went west to live and lived there for nearly fifty years. Remington instead went west for the western experience and to find subjects for his art. For Russell, women were an integral part of daily life. For Remington, they stood as foil to the very masculine freedom that the West represented in his mind. It was a generations-old construct that may even help explain why Remington refused European studies. As articulated in the mid-1830s by Washington Irving, the argument went like this: "We send our youth abroad to grow luxurious and effeminate in Europe; it appears to me, that a previous tour on the prairies would be more likely to produce that manliness, simplicity, and self-dependence, most in unison with our political institutions."[49]

Russell and to a lesser degree Remington explored themes of Indian women in their art. Although Remington's Indian women were infrequent, they were sometimes quite powerful. *Ceremony of the Fastest Horse* (figure 68), an illustration for his book *The Way of an Indian*, portrays a parity of sexes seldom seen in traditional elopement scenes in nineteenth-century art. Here, rather than both bride and groom on one horse, the nervous bride-to-be holding on tightly and looking fretfully to the rear for pursuers, they ride separate horses with equal skill, each focusing forward into their shared future.

Russell took this theme in a slightly different direction. His Indian women often play a supporting role, riding as part of a larger patriarchal unit, as in his painting *His Wealth* from 1915. Just as frequently, however, the women stand on their own. One of his finest early achievements with that approach was his 1898 painting *Indian Women Moving* (figure 69). The central figure, a young Plains Indian woman riding erect in her saddle and peering intently into the distance, is imbued with a remarkable blend of grace and power. She represents the compositional and metaphorical apex of the three generations assembled in the scene. She and the pinto she rides are at once represented as nurturing and as stoic, vital, and knowing. Moreover, she is a leader who is clearly part of a larger kinship network, her ear open to hear the elder woman's advice. The painting celebrates the collectivistic nature of women—in this case, Native American women—bonded as a family. Russell was sufficiently familiar with the workings of Plains Indian society to understand, appreciate, and celebrate such relationships.

As an observer of and, to some degree, a participant in Native American life, Russell quite early in his Montana experience acknowledged the separation between realities and mythic expectations. *Indian Warriors* (figure 83), his watercolor of around 1889, demonstrates a clear differentiation in the young artist's mind between the Indians he met on a day-to-day basis and those whom painters might find worthy of their brushes. The bonneted warrior galloping across the prairie with raised lance and decorously combative attire would attract the "artist" and make an appealing "picture." The illustrator, as a pictorial witness on the other hand, would find Indians looking and acting quite another way. Russell's Indian, who has a pleasant demeanor, wears trade cloth leggings, and carries a sheathed rifle level across his saddle, is presented as a fellow citizen of the northern plains. He was both normalized and actualized by this portrait, given an individual personality that transcended the stereotyped view reserved for the "artist." That the overall painting was a split presentation, contrasting the two interpretations, revealed the sophistication of Russell's conceptualization despite the relative naivete of the work from a formal perspective.

In these early years Russell favored a natural portrait of Indians and produced a number of frontal, rather matter-of-fact pictures of Indians with whom he rubbed shoulders, including *Buffalo Coat* (figure 70), painted in 1908. It was probably this same inclination that caused Russell to find interest in camp and family life and to make a place for those themes then and in his subsequent art.

Remington, although less inclined toward domestic scenes, shared with Russell a reportorial slant to his early depictions of Indians. He traveled more widely in the West than did Russell, availing himself of subjects as far ranging as the Apaches in present-day Arizona, the Comanches and Southern Cheyenne in present-day Oklahoma, and the Blackfeet of southern Canada. Remington's trips to these areas were made in the 1880s, when he served as an artist-correspondent for several eastern magazines, including *The Century Magazine*, *Harper's*, and *Outing*. His resulting paintings were thus generally factual representations of reservation life and Indians in the process of acculturating to new lifeways. His portrait *A Comanche* (figure 71), painted around 1889, is devoid of stereotyped constructs. Mounted on a piebald pinto pony,

71 (above). Frederic Remington, *A Comanche*, ca. 1889. Gouache and wash on paper, 18¼ × 17¼ inches. Frederic Remington Art Museum, Ogdensburg, N.Y.

70 (opposite). Charles M. Russell, *Buffalo Coat*, 1908. Oil on canvas, 21¼ × 15 inches. Gilcrease Museum, Tulsa, Okla.

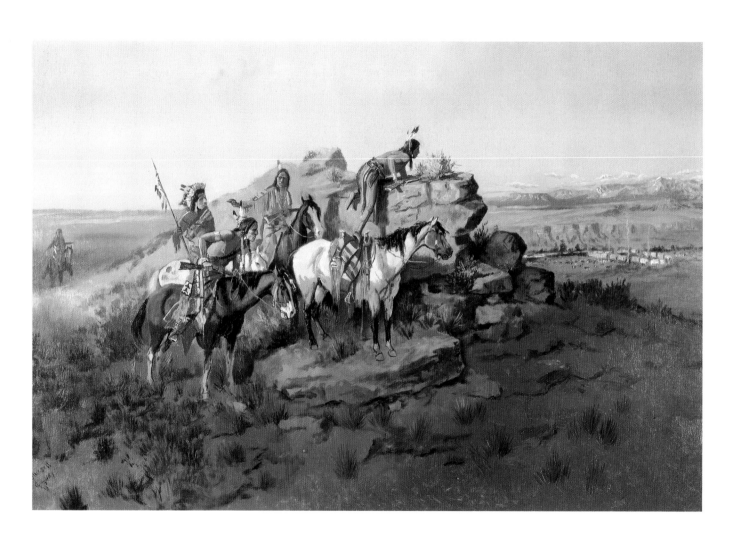

72. Charles M. Russell, *Watching the Settlers*, 1895.
Oil on canvas, 22 1/2 × 35 inches. Lawrence
Klepetko, Denver, Colo.

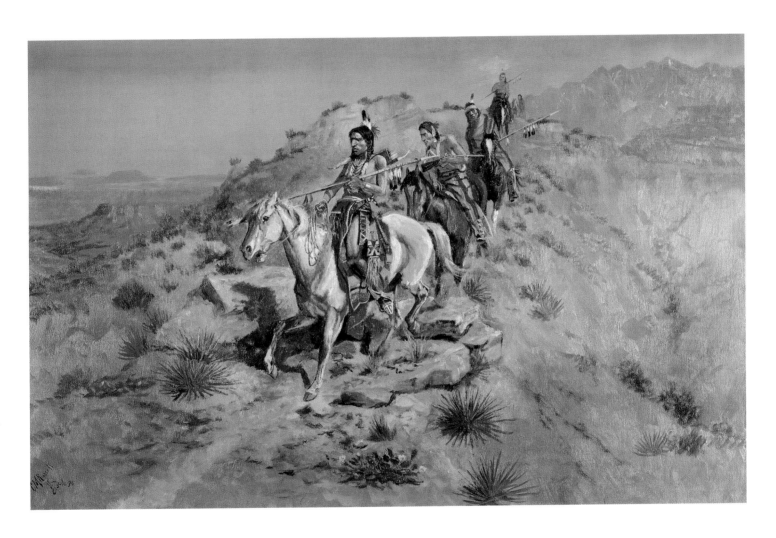

73. Charles M. Russell, *On the Warpath*, 1895.
Oil on canvas, 21 × 34 inches.
Christopher John Minnick, Livermore, Calif.

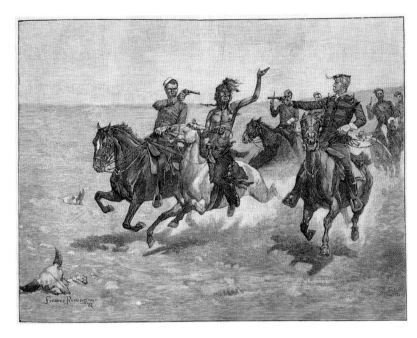

75 (right). Frederic Remington,
Arrest of a Blackfeet Murderer, illustration from
Harper's Weekly, March 31, 1888.
Wood engraving, 6 ¾ × 9 inches.
Memphis Public Library, Memphis, Tenn.

74 (opposite). Charles M. Russell, *Single Handed,*
1912. Oil on canvas, 29½ × 32 inches.
Mr. and Mrs. W. D. Weiss, Jackson, Wyo.

the Indian figure stares confidently but warily at the viewer, his expression conveying some hint of his awareness of an increasingly restricted life. The Oklahoma land rush was imminent, and the Comanches' circumscribed and isolated life was to become more so. Remington too was probably aware of the impending transgressions of the Oklahoma land rush; in fact, these may have provided one impetus for his trip to Indian Territory in 1888.

Yet even in Remington's reportorial mode, there was a fundamental difference between his and Russell's view of the Indians' place in the scheme of things. This was particularly evident when each chose to depict scenes of interactions between Indians and whites. Russell's *Watching the Settlers* (figure 72) and *On the Warpath* (figure 73), both painted in the mid-1890s, stand in marked contrast to Remington's *Arrest of a Blackfeet Murderer* (figure 75), done in 1888. Russell's interpretation of the conflict between Anglo-European pioneers and native peoples clearly embraces the Indians' perspective, inviting the viewer to take their side. Remington's Blackfeet is presented with such savage contempt that viewer sympathies are naturally pulled toward the mounted cavalrymen. When, in later years, Russell produced *Single Handed* (figure 74), his commanding rendition of an arrest scene,

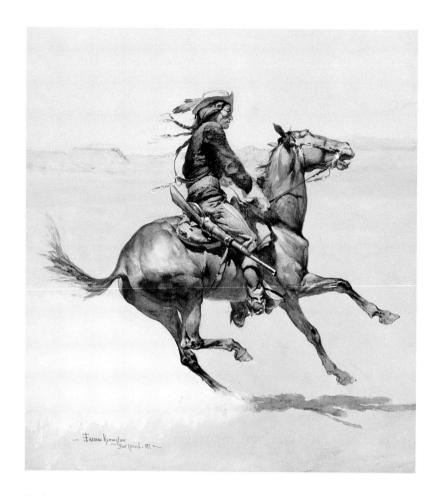

76 (left). Frederic Remington, *The Cheyenne Scout*, 1890. Watercolor on board, 24 × 22 inches. The Philbrook Museum of Art, Tulsa, Okla. Gift of Mr. and Mrs. Waite Phillips.

he bestowed a sense of dignity on all those present, including even the apprehended suspect. Remington's rendition came from a more distant and less sympathetic perspective. His Indian warrior is defiant, and his captors bristle with rectitude as they interact at gunpoint while at full gallop.

When Remington moved beyond such editorializing and endeavored to give Indians a proper place in his academic paintings of the 1890s, the results could be quite striking. A representative example is *Modern Comanche* (figure 77). Here defiance has been replaced with pride and a sense of self-confidence. Here is a man who connects with his past but can see a positive, even opalescently rosy, future. The sun is not setting on this modern Comanche; it is showing him the way to a promising tomorrow. Here, as Russell was not able to achieve in his split portrait, is an Indian who is also a compelling "picture."

In the 1890s Remington was firmly focused on the present-day

77 (opposite). Frederic Remington, *Modern Comanche*, 1890. Oil on canvas, 33 × 23 inches. Bill and Irma Runyan Art Collections, Texas A&M Foundation, MSC Forsyth Center Galleries, Texas A&M University, College Station, Tex.

scene. He favored a "modern" resolution to what was called in his day "the Indian Problem"—that is, mustering Indians into the U.S. Army. Given his narrow view of the world as essentially male dominated, Remington placed a high value on the martial side of Indian life. If, as he reasoned, the Plains Indians were first and foremost a warrior society, then their best chance of finding a meaningful bridge into modern American life would be for the young men to muster into the army. This would get them off the reservations and provide an efficient and effective transition into what Remington viewed as normal American life. Paintings such as *The Cheyenne Scout* (figure 76), painted in 1890, presented his sentiments perfectly, and he announced them in print as well. In his article "Artist Wanderings among the Cheyennes," which appeared in the August 1889 issue of *The Century Magazine*, Remington suggested that the Indian Department should long ago have been placed under the War Department. Although he admitted that Indians made willing and good farmers "when not interfered with or not forced by insufficient rations to eat up their stock cattle to appease their hunger," Remington also pointed out that their men could be regarded as "naturally the finest irregular cavalry on the face of this globe."[50]

Remington never took much interest in domestic camp life among the Indians, but in his dedication to present reality he did portray the young men hunting the U.S. government-issue steers as they had previously hunted buffalo. For the most part Russell chose to ignore the Indians' present reality, preferring instead to put his energies into painting historical scenes and scenes from the old buffalo days—the traditional buffalo hunts.

Russell clung to the notion that the Indian was the elemental natural man. For him there was no potentially redeeming virtue in the Indians' inevitable transformation into civilized society. His response was twofold: to escape into historical motifs and to search for evidence there of nature's morally redeeming qualities. The buffalo hunt, as the historian Robert Hine has suggested, was the perfect expression of that precept. Not only was it the "most compelling subject for the Western artist" (Russell painted several dozen versions over the years); it also "proclaimed that man could conquer beast."[51] Russell saw natural man, fragile and transitory as he was, as supreme and worthy of celebration, while Remington commended the fall of natural man at the hands of civilization. He regarded Indians as savage, and the

78. Frederic Remington, *The Smoke Signal*, 1905. Oil on canvas, 30⅜ × 48¼ inches. Amon Carter Museum, Fort Worth, Tex.

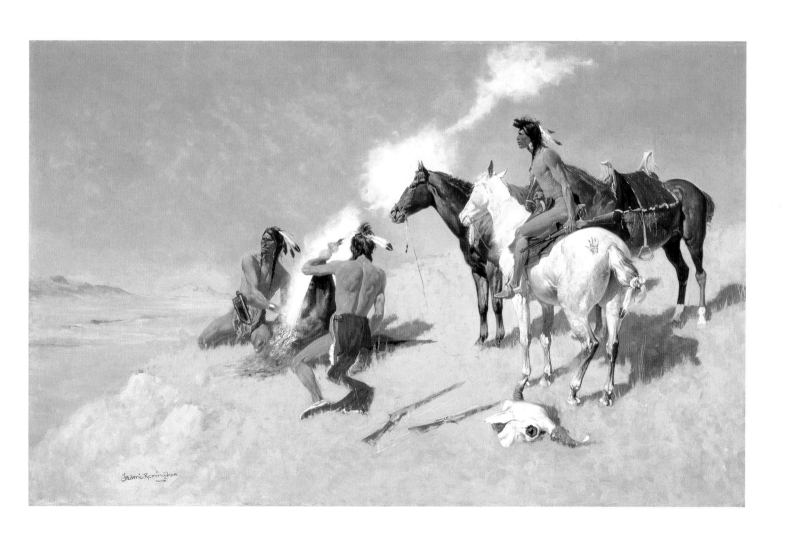

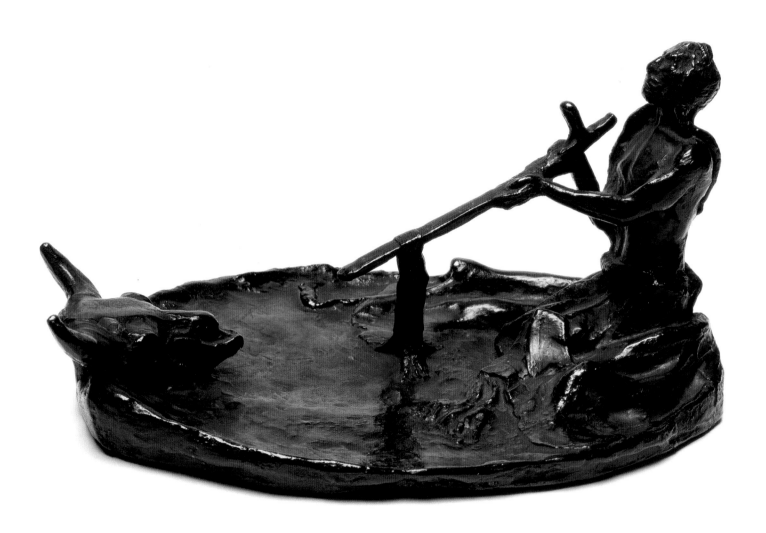

79 (above). Charles M. Russell,
Smoking with the Spirit of the Buffalo, 1914.
Bronze, 4 1/2 × 8 1/4 × 5 1/2 inches. Art Collection,
Harry Ransom Humanities Research Center,
The University of Texas at Austin, Austin, Tex.
J. Frank Dobie Collection.

80 (opposite). Charles M. Russell,
Scalp Dance No. 2, ca. 1905 (Roman Bronze
Works). Bronze, 13 3/4 × 8 1/2 × 8 inches.
Mr. and Mrs. W. D. Weiss, Jackson, Wyo.

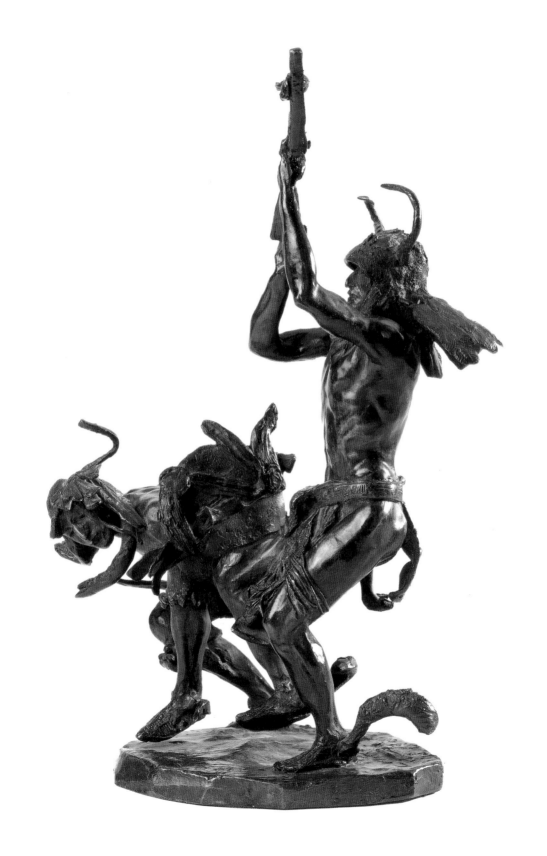

82 (above). Charles M. Russell, *Sun River War Party*, 1903. Oil on canvas, 18 × 30 inches. The Rockwell Museum of Western Art, Corning, N.Y.

81 (opposite). Charles M. Russell, *The Horse Thieves*, 1901. Oil on canvas, 24 × 30 inches. James W. and Fran McGlothlin.

cavalry—in Remington's eyes, the prime agent of civilization and his favorite subject—was their vanquisher. Either join the cavalry, he seemed to be saying, or be crushed by it.

The turn of the century exposed the horrors of modern warfare, revealed to Remington in the sweaty, fever-ridden Cuba campaigns of the Spanish-American War of 1898, during which he served as an artist-correspondent for *Harper's Weekly* and Hearst's *New York Journal and Advertiser*. Gradually the artist from New York adopted the Montanan's perspective. In his ranking of humanity, natural man— represented by the Native American, particularly the bygone Indian of buffalo days—achieved an elevated status. Remington's *The Smoke Signal* (figure 78), painted in 1905, and *The Sign of the Buffalo Scout*, painted in 1907, exemplify his later elegiac response to the Indians of

83 (left). Charles M. Russell, *Indian Warriors*, ca. 1889. Watercolor, 5 × 7 inches. Collection of David P. Bolger and Mark A. Costello, Chicago, Ill.

old. In the latter work the buffalo scout, silhouetted against a golden veil of sky, looks beyond the signal mound of skulls into a distance of uncertain fortunes. The riderless horse lends a note of finality, as do the skulls themselves. The top skull seems to fix its gaze in the same direction as the scout, perhaps signaling in a reverential way the loss of hope for the hunter's future.

Russell's *The Horse Thieves* (figure 81), painted in 1901, and *Sun River War Party* (figure 82), painted in 1903, relay the same message. In both paintings a group of warriors in full battle regalia rides in the glow of dusk toward an unknown destination. Although their expression and gaze show determination, the somber opalescence of the settings hints as much at reverie and resignation to the inevitability of passing time as at the trophies or anticipation of battle. Russell's more ambitious canvas of 1925, *The Wolfmen* (figure 84), breathes welcome vitality into the scene. Bathed in light and marching forward in animated procession, these warriors seem to ride out of the past and into the present. Yet despite this sense of immediacy and certain glory, such images by Remington and Russell tended to deprive the Indians of their day of a place in the modern world. It would be left to other artists— Joseph Henry Sharp (1859–1953), for example—to recount more

84 (opposite). Charles M. Russell, *The Wolfmen*, 1925. Oil on canvas, 24 × 36 inches. Thomas Petrie, Denver, Colo.

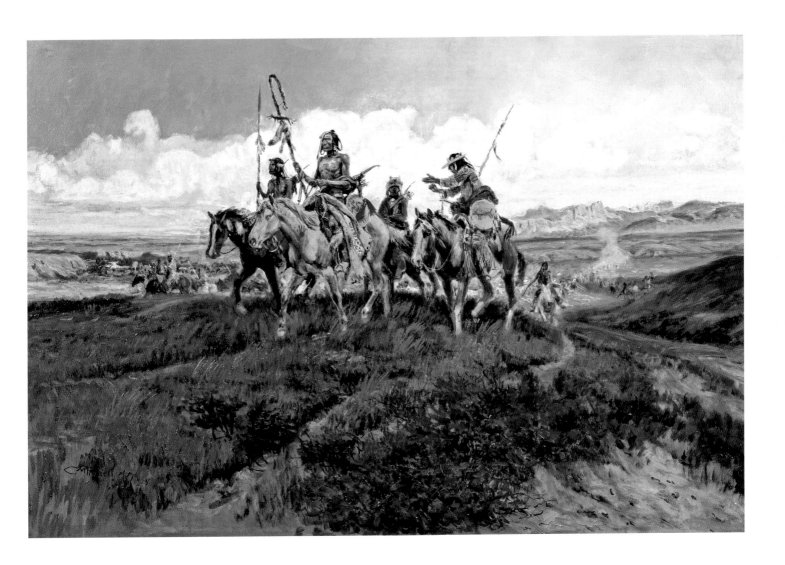

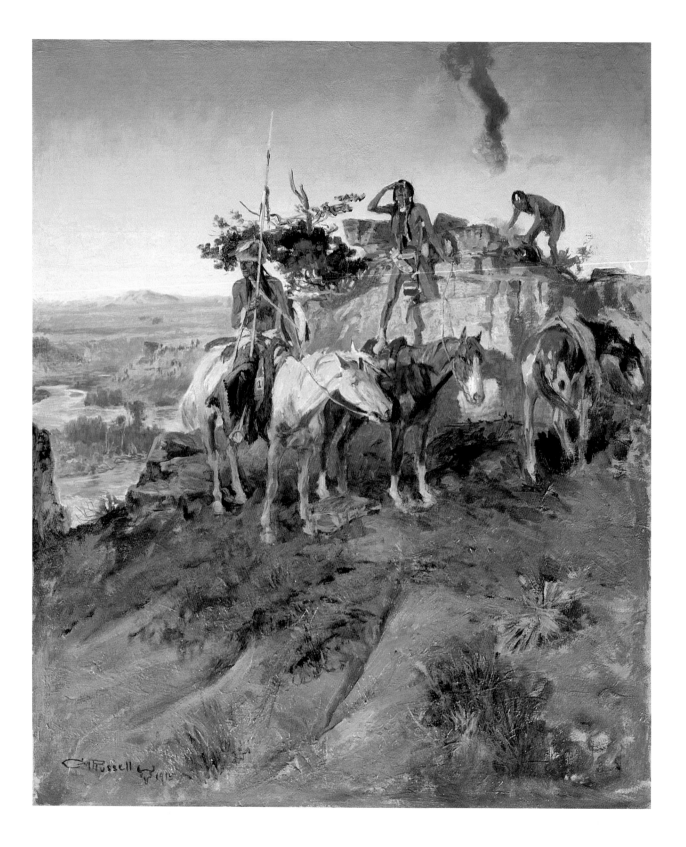

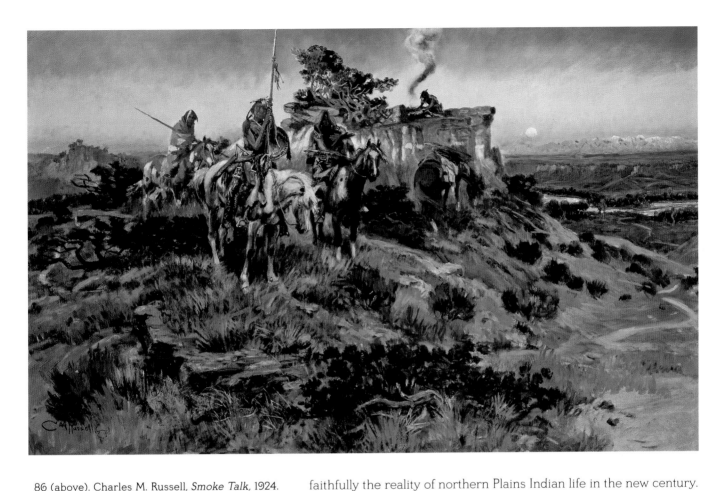

86 (above). Charles M. Russell, *Smoke Talk*, 1924. Oil on canvas, 30 × 48 inches, National Cowboy Hall of Fame and Western Heritage Center, Oklahoma City, Okla.

85 (opposite). Charles M. Russell, *Signal Smoke*, 1915. Oil on canvas, 34 3/4 × 29 inches. Thomas Petrie, Denver, Colo.

faithfully the reality of northern Plains Indian life in the new century.

Russell, who outlived Remington by seventeen years, continued to explore dimensions of reverie through his portrayals of Indians. In *Signal Smoke* (figure 85), painted in 1915, and *Smoke Talk* (figure 86), painted in 1924, he featured groups of warriors communicating across distances through puffs of smoke. Through their posture and their disdainful regard of the viewer, however, they seem to imply that they would have been happier if left alone in this special place. In an atavistic way Russell felt wedded to that sentiment. He painted Indian subjects more than any other and generally, as with his *Salute of the Robe Trade* (figure 88), from the Indian's perspective. He was also a serious student of their lifeways. Throughout his life he nurtured a bond with Indians, wishing at times that he could have been one of them.[52] In 1919, in a letter to his cowboy friend Edward C. "Teddy Blue" Abbott (figure 87), he mused that if he had it to do all over again, he might well have been happiest as an Indian of the old buffalo days.

87. Charles M. Russell, *Letter to Edward C. "Teddy Blue" Abbott,* May 13, 1919. Pen and ink and watercolor on paper, each page 10 × 7½ inches. The Gund Collection of Western Art, Indianapolis, Ind.

Great Falls mont
May 13, 1919

Friend Ted I got the picture
and letter both the 9th and you and youre
old hoss will deck the walls of my shack
al ways
and when ever I look at the picture my
memory will drift back over trails long
since plowed made by the nester to days
when a pair of horse ranglers sat in
the shaddoes of thair horses and waded
the grasing bunches of cyuses these
cyuses had all heard the fiddle mouth
harp and the many songs sung by
thair riders even the war drum of the red
men was no novelty to them
but the day I speak of it was different every
hoss with head and ears streightened listened
for one of the ranglers was a musician and
the insterment he played unloded notes
on the breaze that would make the cyote
taking his day nap in the rim rocks think
hes having bad dreams or wander if the
last feed of cow meat he had wasent over
ripe or maby Mrs Cyote would ask
him and say turn over dear your layin
on your back and the nois your making

will wake the babys the noise maker this
ranger played looked like a sweet potato
and judging from its voice its a cross between
a She Caliope wagon and a bull fiddle
the owner of this instermint calls it a Buzzoo
Its a long time ago this happins Ted when
we was using our second crop of teeth and
now we'r both waring our third

I remember one day we were looking at buffalo
carcus and you said Russ I wish I was a Sioux
Injun a hundred years ago And I said me to
Ted thairs a pair of us

I have often made that wish since an if the buffalo
would come back tomorrow I wouldent be slow shedding
to a brich clout and you'd trade that three duce ranch
for a buffalo hoss and a pair ear rings like many
I know, your all Injun under the hide

an its a cinch you wouldent get home sick in a skin
lodge Ma Nature was kind to her red children
and the old time cow puncher was her adopted son
 will Ted I'l close the deal
 best wishes to you and Yors
 your friend C M Russell

keep on wrighting that Cow puncher history it
sounds good to me

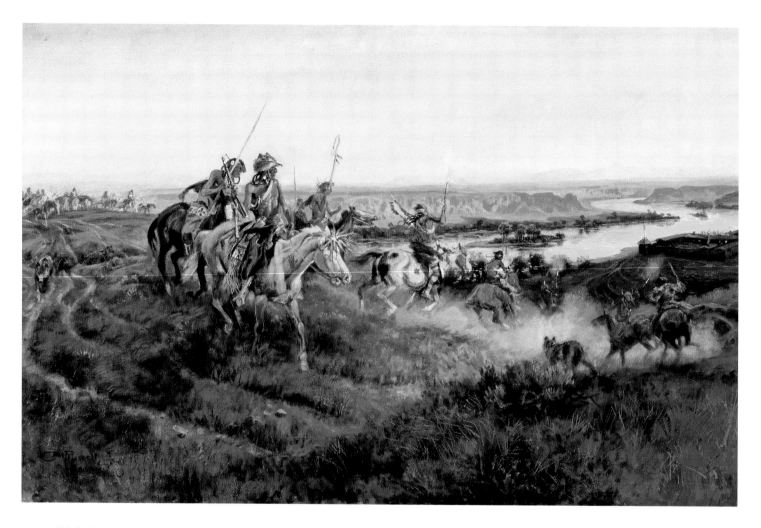

88. Charles M. Russell, *Salute of the Robe Trade*,
1920. Oil on canvas, 29 1/2 × 47 1/4 inches.
Gilcrease Museum, Tulsa, Okla.

With *Signal Smoke* and many other late works, Russell espoused the moral superiority of the past over the future. He firmly believed that the past might redeem the actions of the present. He had gone west thirty-five years earlier to find himself and document through his art the vital life of the cowboy. At the close of his life and career he chose to focus often on the chapters of western life that preceded his own experience and to proclaim the passing of an earlier culture as the most compelling epoch in the West's history.

Remington had searched the West in his early days for evidence of an epic and potent present reality. He ended his short career celebrating, through such masterful and dramatic works as *Pool in the Desert* (figure 89), a historic and bygone era similar to that seen in Russell's *Salute of the Robe Trade*. Yet, as often as he painted nostalgia and

89. Frederic Remington, *Pool in the Desert*, 1907.
Oil on canvas, 26½ × 40 inches.
The Hubbard Museum of the American West,
Ruidoso Downs, N.M.
The Anne C. Stradling Collection.

poetic, quiet memories in these late years, reverie just as often gave way to breathlessly kinetic action pieces featuring his formidable artistic skills and his conviction that pounding action conveyed the most powerful narrative messages.

Both Remington and Russell personally experienced the closing chapter in the story of the old West. Theirs initially was a present-tense, one-on-one exposure, Remington's as an artist-correspondent with the cavalry and Russell's as a night wrangler with big cattle outfits. As their art and their lives matured, however, they were increasingly called on to interpret not only their own experiences but also early western epics. Thus they assumed the role of historical recorders, using their remarkable art to create meaning, relevance, and an enduring symbology for the scene they elected to celebrate—the West.

Cowboy Illustrators, Cowboy Artists

For the first fifteen years of his career, up until the turn of the twentieth century, Remington's favorite subjects were military scenes, particularly the cavalry and its pursuits. With Russell, despite his nickname "the cowboy artist," Indians found their way onto his canvases and into his drawings more frequently than any other subject.[1] Nonetheless, the two artists have been remembered primarily for their images of the cowboy and their fundamental roles in creating both the cowboy's national popularity and the concomitant myth.

Remington's reputation included both the false credit that he had lived the life of a robust cowboy and the clear fact that he excelled as a horseman. Russell had known and worked with cowboys but always disclaimed ever having been among their ranks. Although both began to portray the cowboy in their art at about the same time, in the mid-1880s, Remington's images had the greater impact, primarily because his audience was nationwide. Remington popularized the figure of the cowboy and "broke ground," as the cowboy historian Lonn Taylor has put it, in establishing the "enormous demand for cowboy illustrators," Russell included.[2]

Russell's *The Slick Ear* (figure 94) proves the artist's mastery of narrative tableaux dominated by excited physical action, impending danger, and vital brushwork. Remington rarely matched such tour-de-force efforts.

THE RISE OF A STEREOTYPE

Early renderings of cowboy life, both literary and pictorial, were essentially genre treatments. The cowboy was a drover, or herdsman, whose relatively exotic environment and grueling, sometimes grim days in the saddle separated him from his eastern and midwestern counterpart—the farm boy—but did not necessarily elevate his stature. When cowboys described themselves, they created colorful but far from mythic self-portraits. Baylis John Fletcher, a Texas cowboy who arrived in Wyoming in 1879, the year before Russell went to Montana, wrote vividly of his experience:

After five months of rough life on the trail, we Texas cowboys, deprived as we had been of all the conveniences and comforts of civilization, were a picturesque squad as we rode into Cheyenne. Our neglected and dilapidated clothes were worn and patched, our hair was uncut, and our faces unshaven. We presented no particularly novel sight to the natives, however, as they were accustomed to the arrival of travel-worn cowboys.[3]

A certain roughness soon accrued to the cowboy's mildly "picturesque" ragtag, vagabond image. In 1882 cowboys gained national attention when President Chester Arthur, in a special message to Congress, roundly condemned their rowdy behavior in certain southwestern towns. Many western communities concurred. One Wyoming newspaper, the *Cheyenne Daily Leader*, observed in its October 3 issue of that year: "morally as a class," cowboys were "foulmouthed, blasphemous, drunken, lecherous, utterly corrupt."[4]

More than a few western promoters felt that this was an unfair assessment of hard-working albeit somewhat freewheeling characters. The label of moral dissoluteness was not only invalid, they claimed; it was in fact the evidence of regional bias. "Why this should be so," wrote Robert Strahorn, a booster who actively promoted Montana and Wyoming at the time, "is partially explained by the fact that eastern readers demand experiences from the western plains and mountains which smack of the crude, the rough and the semi-barbarous."[5]

Perhaps easterners had acquired an appetite for such interpretations from James Fenimore Cooper's writings or the ubiquitous dime novels, with or without cowboy themes. In an effort to counteract such profane portraits, those who admired cowboys set out to picture them quite differently, to enhance their image by applying the embellishment

90. Frederic Remington, *The Rattlesnake*, 1905 (Roman Bronze Works, no. 46). Bronze, 23 3/8 × 17 3/4 × 12 1/16 inches. The Art Museum, Princeton University, Princeton, N.J. Bequest of Paul Bedford, Class of 1897.

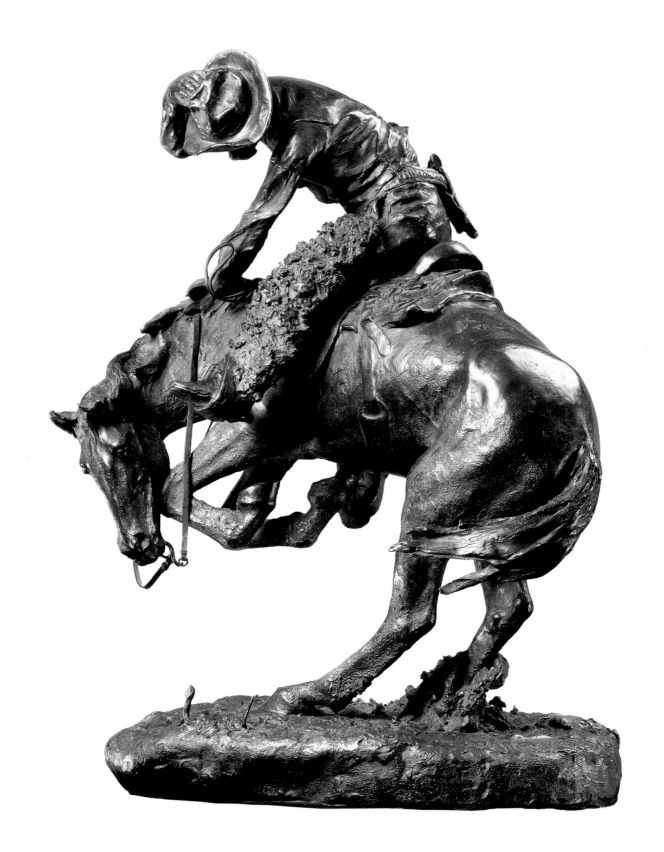

of virtue to the otherwise plain cloth of cowboy character. As a result, the cowboy began to take on qualities of extraordinary physical prowess, special endowments of wit and humor, and chivalrous traits equated with the knights of old. No less lofty a supporter than Theodore Roosevelt in his articles in the 1880s defended the cowboys' character, claiming that their rough edges were justifiable results of their environment. From the late 1860s to the early 1880s, western newspapers thoroughly covered this theme, running numerous articles with titles such as "Cowboys and Their Slanderers" and "False Notions of Western Character." By 1890 a dual myth had begun to evolve. One side of the myth apparently responded to eastern tastes for violent and crude horsemen of the plains who possessed at least a streak of the criminal impulse that President Arthur had denounced. The other, an apologist's reaction, depicted the cowboy as a rough but sincere Galahad of the prairies. As the century came to a close, these two forces settled firmly into place. The cowboy had received his stereotype both in prose and in pictures.

91. Frederic Remington, *Prairie Fire*, ca. 1885. Oil on artist's board, 26 $^{13}/_{16}$ × 22 inches. The Nelson-Atkins Museum of Art, Kansas City, Mo. Lent by Mr. and Mrs. E. A. Hough, in memory of Mrs. J. F. Boyd (20-1935-1).

SYMBOLISM VS. REALISM

By the mid-1880s both Remington and Russell were producing serious work focused on the cowboy. Often they depicted rowdy behavior, but more common were the portrayals of thrilling episodes from cowboy life, as with Remington's *Prairie Fire* (figure 91) and similar pictures by Russell showing cattle and cowboys stampeded by lightning. The two young artists seemed to share a perception of the cowboy as an adventurous figure who was both picturesque and inherently plucky.

Remington's 1887 commission to illustrate *Theodore Roosevelt's Ranch Life and the Hunting Trail* (figure 33) challenged the artist to educate himself about the broad array of activities and textures inherent in cowboy life. He relied on many of his own experiences and firsthand observations, as well as photographs of pioneer documentarians such as L. A. Huffman of Montana.[6] Many of the resulting works, including *A Bucking Bronco* (figure 36), depicted dramatic scenes. Others showed everyday activities of men working cattle on the open western prairie. Branding and roping, gathering horses and feeding the crew—these were the daily, less than dramatic activities that Remington highlighted when illustrating Roosevelt's text. These

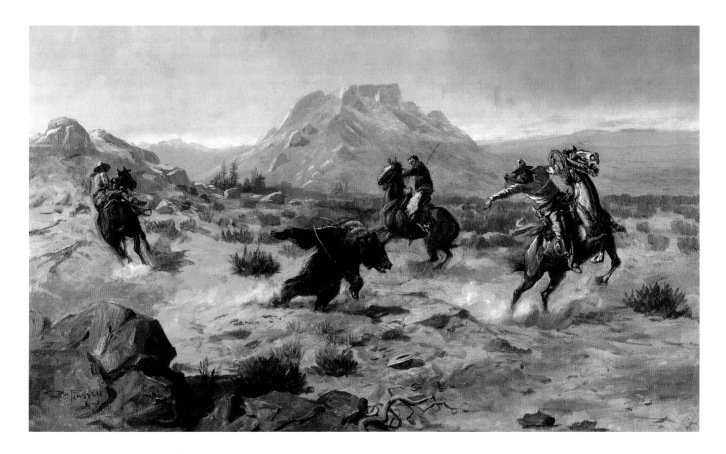

93 (above). Charles M. Russell, *Capturing the Grizzly*, 1901. Oil on canvas, 17⅝ × 29½ inches. Thomas Petrie, Denver, Colo.

92 (opposite). Frederic Remington, *The Cowboy*, 1902. Oil on canvas, 40¼ × 27⅛ inches. Amon Carter Museum, Fort Worth, Tex.

scenes were not appreciably different from views of cowboy life published by Russell in 1890 in his first book, *Studies of Western Life*.

From the mid-1880s through the following decade, Russell concentrated on a favorite cowboy theme: the bucking horse and rider. Painted primarily for the enjoyment of his fellow range riders, these scenes served as variations on a theme and featured portraits of his associates, to their delight and fascination. These paintings afforded Russell an opportunity to depict not only the explosive, jolting fury of an angry cow pony trying to unseat one of his cronies but also the individual men of the roundup, performing actual cowboy activities, against the backdrop of the Montana landscape.

Throughout his career Russell continued to place his cowboys in a specific landscape—his beloved Montana—and to portray them as individuals. Remington's settings tended to be more and more generic over time and his riders' actions less specific, less indicative of the actual work at hand. Remington's painting *The Cowboy* (figure 92), done in 1902, pictures a dramatic and perilous scene of horses being

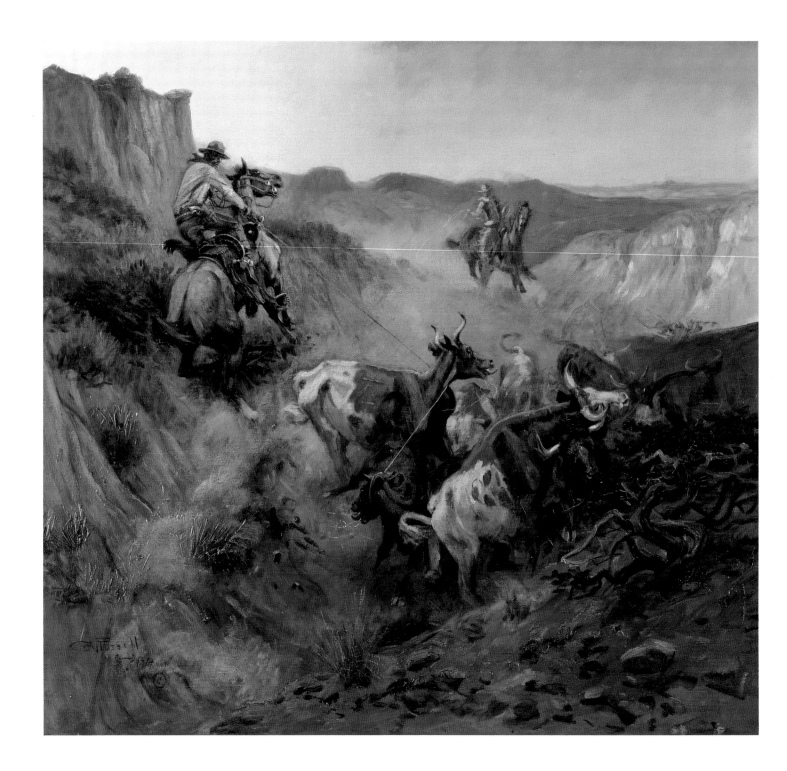

95 (right). Charles M. Russell, *Git 'Em Out of There,* ca. 1915. Watercolor on paper, 18½ × 25 inches. Jack S. Blanton Museum of Art, The University of Texas at Austin, Austin, Tex. Gift of C. R. Smith, 1985.

94 (opposite). Charles M. Russell, *The Slick Ear,* 1914. Oil on canvas, 30 × 33½ inches. Jack S. Blanton Museum of Art, The University of Texas at Austin, Austin, Tex. Gift of C. R. Smith, 1985.

stampeded out of the hills. Yet his intent in his paintings after the turn of the century was not so much to present details as to convey broad messages about man's role in the historic West. Here the cowboy pursues wild horses at breakneck speed, the plummeting action expressing man's domination over nature. This is the same fundamental metaphor for struggle represented in his bronzes *The Broncho Buster* (figure 8) and *The Stampede* (figure 106). Russell's *Capturing the Grizzly* (figure 93) mirrors the same idea. Yet works such as *Git 'Em Out of There* (figure 95) and *The Slick Ear* (figure 94) reflect a specificity of task and location that creates a sense of realism, while the cowboys in *The Mix Up* (1910) ride horses with specific brands. All these narratives suggest specific individuals and events that evolved from actual accounts in cowboy biographies.

Remington's scenes are not so much about real cowboy life as the inexorable and powerful force of man over beast. Russell's renditions are measured in human scale and capture an innocent effort at dealing with the excitement of unexpected workaday tangles. Remington's are epic versions of similar scenes, swelling with a grand crescendo of masculine bravado and the message that nature could be conquered.

Both artists wanted their audiences to see them as authorities on the cowboy and made significant efforts to write about as well as picture

Nove 26
1925

Ralf Budd
 Dear Mr. Budd
this is thanks giving day an Im
thanking you for the good time
you gave us last summer
turkey is the emblen of this day
and it should be in the east
but the west owes nothing to that bird
but it owes much to the lumped backed
beef in the sketch above
the Rocky mountians would have been
hard to reach with out him
he fed the explorer the great fur trad
wagon tranes felt safe when they
reached his range

he fed the men that layed the
first ties across this great west
thair is no day set aside where he
is an emblem
the nickle wares his picture
dam small money for so much
meat he was one of natures bigest
gift and this country owes him
thanks
the picture you sent a photo of that
I painted was made a long
time ago it was made to represent
Frater DeSmet on the Missouri
River
hoping you and yours are all
Well I am your
friend
C M Russell
Mrs. R sends best regards

96. Charles M. Russell, *Letter to Ralf Budd*,
November 26, 1925. Pen and ink
and watercolor, each page 6½ × 5 inches.
JKM Collection, National Museum
of Wildlife Art, Jackson Hole, Wyo.

the western punchers and their contributions to frontier life. In the August 1899 issue of *Collier's*, Remington published a story about cowboys and the cattle business. Entitled "Life in the Cattle Country," it presented a plain, matter-of-fact treatment, a plethora of facts with essentially no narrative. In it he lamented the advent of barbed wire, the fall of the cowboy, and the transformation of the open range. "Every year sees a nearer approach to the end," he grumbled.[7] Further compounding their sad fortunes, he observed, cowboys still suffered from a public perception of them as thugs. Remington felt that they had been unfairly maligned. In fact, he contended, the strength of their moral fiber could serve as models for most easterners.

Some years later Russell penned similar remarks. In his short story "The Open Range," he spoke wistfully of the shrinking of the open range and the fateful introduction of barbed wire. As with Remington's "Life in the Cattle Country," Russell affectionately recounted the routine of an old-time roundup. His language was more vernacular than Remington's and his descriptions were more precise, but the essentials were the same. In another story, "Ranches," Russell expanded on his lament to include a rather uncharacteristic dig at the feminized West. Milk cows, mahjong, and "old Ma," he claimed, had spoiled things for the cowboy. Women brought progress, which Russell and his fellow riders at times could have done without.[8]

Despite the fact that Russell was personally affected by the end of the open-range cattle business in the early 1890s, his paintings show less recognition of the situation than did his stories. Instead, in canvases such as *The Herd Quitter* (figure 97), his cowboys ride through their chores under the rosy, cerulean opalescence of a western sky, a promise of success. The brands on the cattle and horses are emblems of the commercial enterprises that supported Russell as a wrangler and later as an artist, when his patrons were oilmen and stockbrokers. And there is every evidence that the roper's loops will reach their mark, suggesting that the maverick, a diversion from the agrarian norm, can be brought safely under control.

Remington's paintings, although no more laden with metaphorical baggage, tended to be more extreme and more bloody. In *What an Unbranded Cow Has Cost* (figure 98), his gruesomely fatalistic centerpiece for Owen Wister's "The Evolution of the Cow-Puncher," Remington presented his own version of the end of an era.[9] Cowboys from a competing outfit have attempted to rebrand a disputed cow,

C M Russell 1847
LITHO IN U.S.A.
S.O.C.C.

"Herd Quitter"

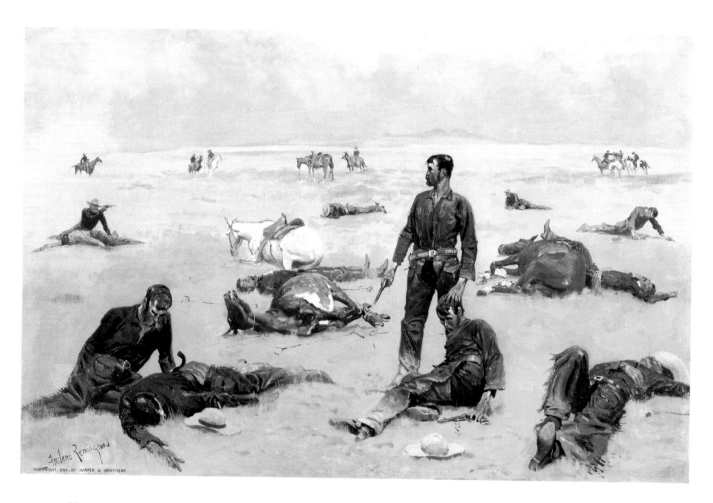

98 (above). Frederic Remington,
What an Unbranded Cow Has Cost, 1895.
Oil on canvas, 28 1/16 × 35 1/8 inches.
Yale University Art Gallery, New Haven, Conn.
Gift of Thomas M. Evans, B.A., 1931.

97 (opposite). Charles M. Russell, *The Herd Quitter*, after 1897. Photomechanical print of oil on canvas, 6 7/8 × 8 7/8 inches. Charles M. Russell Center, University of Oklahoma, Norman, Okla. Gift of Peggy and Harold Samuels, 1998.

instigating a gunfight. Dead men and horses lie scattered on the ground, victims of the demands of the business and the cowboys' own supposedly inherent penchant for seeking violent resolutions to problems. Essentially the West had destroyed itself through greed and hubris. Bad weather, taut wire, and slack prices would be blamed, but Remington concluded that the real causes were human and more deadly. As Russell seems to be saying in his painting *A Rough House*, depicting a cow town shoot-out, the West would do itself in while resisting civility and reasoned human interaction. Russell repeated Remington's theme, although without the profound finality, in at least two other paintings, *The Cinch Ring* (1904) and *When Horseflesh Comes High* (1909).

Remington and Russell did not accept the notion set forth by Owen

99. Frederic Remington, *Letter to Owen Wister,*
October 20–30, 1894.
Pen and ink, each page 8¾ × 7⅛ inches.
Library of Congress, Washington, D.C.

Cheyenne saddle — made in city of Cheyenne from California
models — there no so called all over — there are
many forms of California saddle & also Cheyenne.
Are made in St Louis I believe.

Pure type Cheyenne

Brazos tree

Mexican Tree —

Don't Know how he was affected by Mex. war —
he did not exist as an American Type — by
was later a combination of the Kentucky or Tennessee
man with the Spanish.

In civil war he sold cattle to Confederate
Armies — but was a soldier in Confed. army

but as a pure thing he grew up to take
the cattle through the Indian country from
Texas to meet the R.R — at Abilene — or before
that even he drove to Westport Landing —
These were his palmy days — when he bitterly

And incidentally speak of that puncher who turned
horse & cattle thief after the boom slumped and who
was incidentally hung and who still lives & occasionally
in the most delical: way goes out into this waste of
land and ships them to Kansas City after driving a
good many miles to avoid Live Stock inspectors . &c &c
J. R.

who looks like this in life —

over

It was a good stout man lig int (I couldn't member what it)
on the Second Missouri —

Got a side face of Specimen — I will fix
him for all time — unless you give me a back
view

J. R.

"Fire and Sword" is the greatest book I ever read
when Falstaff says "I will die with my fleas"

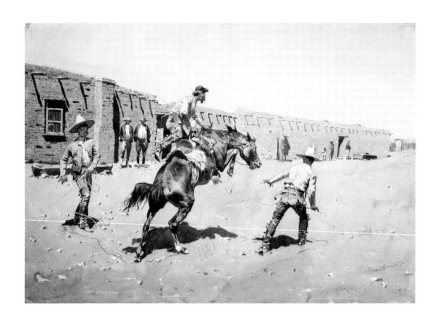

100 (left). Frederic Remington, *Mexican Vaqueros Breaking a Bronc*, ca. 1893. Pen and India ink wash heightened with white, 26¼ × 38½ inches. Museum of Fine Arts, Boston, Mass. Bequest of John T. Spaulding.

Wister and perpetuated by myriad writers and illustrators of the day that the cowboy was the noble descendant of the Anglo-Saxon knight. This sentimental notion fit neither Remington's cultural fatalism and Darwinian social views nor Russell's Everyman interpretation. Lonn Taylor, in his discussions of Remington's cowboys, concluded that his punchers were "young, reckless, daring, alive with movement, and always white."[10] But while many of Remington's cowboys fit Wister's prototype, just as many did not. In his paintings and stories Remington included *vaqueros* (Hispanic cowboys) and also paid tribute to the black soldiers of the U.S. Cavalry. *Mexican Vaqueros Breaking a Bronc* (figure 100), painted around 1893, and his story "An Outpost of Civilization," which recounted his visit that year to the vast Bavicora Ranch in Chihuahua, Mexico, testify to Remington's fascination with cowboys of other colors and cultures. His studio walls were festooned with the trappings of *vaqueros* and Anglo-American cowboys from north of the border.

Russell too, after his first trip to Mexico in 1906, became enamored of the *vaqueros*. He had visited Don Luis Terrazas's famous ranch in Chihuahua and came away enthralled with the *vaqueros*, their abilities as horsemen, and especially the elegance of their costumes, which he depicted in his *Mexican Buffalo Hunters* (figure 101). In a handsomely illustrated letter to his friend Bob Stuart, he admitted that he

101 (opposite). Charles M. Russell, *Mexican Buffalo Hunters*, 1924. Watercolor and gouache, 13¾ × 18⅜ inches. Frederic G. and Ginger K. Renner Collection, Paradise Valley, Ariz.

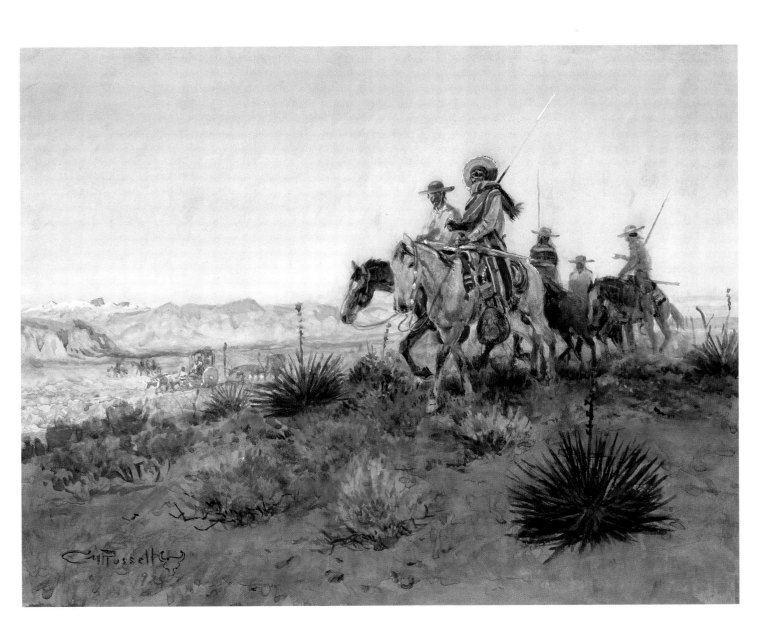

used to "think the old time cow punchers were pritty fancy in this country [Montana] but for pritty these mexicans make them look like hay diggers."[11]

Long after Remington died, Russell continued to document and explore the artistic potential of cowboys north and south of the border. As the years passed, the working horsemen of the plains were enshrined in reverie. Paintings such as *The Broken Rope* (figure 17), done in 1904, and *The Slick Ear* (figure 94), done in 1914, blended the vibrancy of his earlier, work-a-day cowboy paradigm with a sense of nostalgia. In the end the complexity of his compositions set him apart from his contemporary. As Gutzon Borglum noted in 1926, Russell demonstrated "an ability Remington had never shown, the power to draw animals, horses, cattlemen in the mixed-up, tangled-up situations daily occurring in the wild unfenced West—situations that no other artist has ever attempted."[12]

ELEGIES TO NATURE

In one of Remington's final tributes to the American cowboy, *Against the Sunset* (figure 102), painted in 1906, a horse and rider no longer race or strain. Instead, they seem suspended in air, floating across a sky that bursts with celebratory color, as if accompanied by a symphony. The sagebrush provides staccato embellishments, but the rest of the picture sings with harmony of tone and form and motion, at once inspiriting and elegiac.

Russell's concluding statement on the cowboy was painted in 1923. Entitled *Men of the Open Range* (figure 103), it pictured men and their horses striding forth to begin their day's work. It was a testament to stamina and devotion, to love of life, and to the broad sweep of Montana grassland that supported their enterprise and their dream. As with Remington's *Against the Sunset*, this painting exudes a measure of musical fantasy. Its figures spring to life out of the morning's glow and carry with them the rhythms and harmonies that would endure in the public memory like the score of a national anthem.

These two paintings also provide a vehicle for understanding the formalistic qualities of Russell's and Remington's mature work. By the early 1920s Russell's palette had exploded with brilliance, his draftsmanship was supremely deft, his compositions were solidly academic,

102. Frederic Remington, *Against the Sunset*, 1906.
Oil on canvas, 22 × 30 inches.
Gerald Peters Gallery, Santa Fe, N.M.

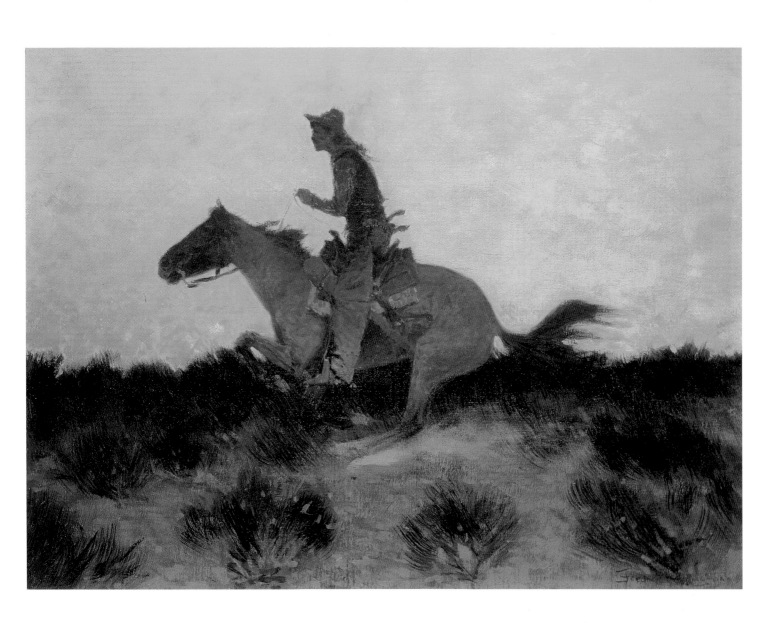

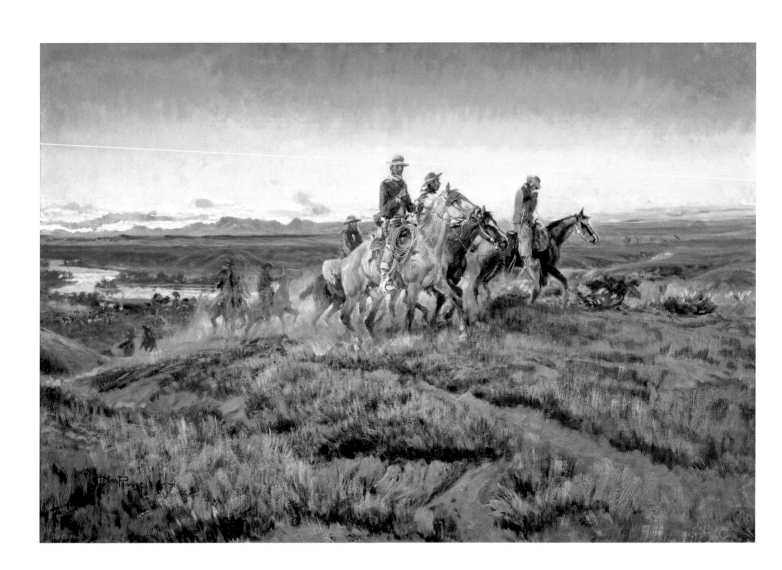

103. Charles M. Russell, *Men of the Open Range*,
1923. Oil on canvas, 22 × 30 inches.
Montana Historical Society, Helena, Mont.
Mackay Collection.

and his mode was reportorial. Remington's palette seemed bolder by degrees, and his colors were spread on more broadly defined planes. His drawing remained fundamentally strong although, beneath the washy brush strokes, less evident than Russell's. And his composition essentially mirrored Russell's, yet his mode was analytical rather than reportorial. Where Russell sought to delineate, Remington wished to synthesize. For Remington the less attention paid to details and the more broadly conceived a work, the better the result. Russell, on the contrary, refused to abandon the realism of figurative precision.

During the last years of his life, Remington sought acceptance as a painter's painter. But he refused to sacrifice his devotion to his subject, the cowboy, which he believed was for him the only foundation of credible artistic endeavor. Even though his cowboy in *Against the Sunset* materialized only in a phantom blur, as if a visible yet incorporeal ghost, this figure remained the focus of the work. All else in the composition was subservient to him. Remington's attempt to preserve the primacy of the figure in his impressionistic works was rather unique. Between 1903 and 1909 his style changed from a personalized form of impressionism to a hauntingly ideational synthesis of form and color harmonies that suggest an affinity with the symbolist painters of the day. As the critic Royal Cortissoz noted, despite Remington's persistent dedication to western themes, his was "a talent that is always ripening, an artistic personality that is always pressing forward."[13]

Cortissoz had recognized Remington's talents several years earlier and written him a personal letter, attesting to his admiration for the man he called the "Maestro": "I don't know any better sensation than that of looking on while a fellow human is making one splendid stride after another, painting good pictures and these damned good ones, and then damneder, and all the time doing it to his own beat, being himself in the fullest sense, making something beautiful that no one else could make. More power to your elbow."[14] In 1908, after his annual exhibition opened at Knoedler's Gallery in New York to rave reviews, Remington acknowledged his full transformation into a painter. In a letter to his friend John Howard he boasted: "My show made a great hit this winter.... I am no longer an illustrator."[15]

Russell believed that artists like Remington did not really know where they were going with such works as *Against the Sunset*. He told the painter Maynard Dixon (1875–1946) in 1908: "I do not object to broad free painting—but I want to have sense—I want to see what it

is." The "esthetic fellows" confused Russell. "I don't believe they know what they want," he continued. "They don't seem to know a damn thing but painting. They are just 'artists.' I'm an illustrator. I just try to tell the truth about what I know."[16] Because he could not comprehend what Remington's late paintings meant, his recorded criticisms of Remington revolve primarily around nuances of fact. He told Joe DeYong at one point, in a probable reference to *No More He Rides* (figure 10), that Remington "was a good artist but made lots of mistakes … he knew nothing about a rope."[17] At other times he complained about Remington's cowboys wearing slough hats or mishandling a quirt (whip). At one point he even ventured to denounce Remington's colors as being too "fiery" but then backed away, admitting that one "can't judge by reproductions."[18]

Most observers followed Russell's cue when it came to assessing his own talents, allowing him to hide behind humility and his professed limits of being nothing more than an illustrator. But a few, including his hometown newspaper from time to time, would not let him off so easily. The *Great Falls Daily Tribune* rendered the following contrarian opinion in 1901:

Russell is not a mere copyist, even of nature, and most of his work is more akin to creation than reproduction. While it is true, his scenes, depicted so admirably on canvas, are so truthful as to be almost lifelike. Yet the impression is not one of over elaborate detail, but of grandeur and sublimity conveyed through the temperament of a highly sensitive nature—the nature of the true artist.[19]

This would suggest that some observers recognized Russell's full merits as a painter rather than as a simple cowboy illustrator. In the two artists' mature work, incompatibility in technique and dedication to what Russell referred to as "truth" was made up for by a union of overall values and spirit. They were, at heart, quite similar. "Russell was a cowboy who loved to paint," wrote Lonn Taylor, while Remington was "a painter who loved cowboys."[20] Both relied ultimately on their imagination and their belief in the revitalizing impact of narratives from the past. In 1913 Nancy Russell addressed the Great Falls Women's Club on the subject of her husband's art. She said that he was a storyteller in paint and that he lived in history. "No man can be a painter without imagination," she instructed the group. "He must live in his pictures."[21] A few years earlier Remington had written to a friend, Al Brolley, that he was "the bone in a big art war" down in New

104. Frederic Remington, *The Gossips*, 1909.
Oil on canvas, 27 3/4 × 39 1/2 inches.
Peabody Essex Museum, Boston, Mass.

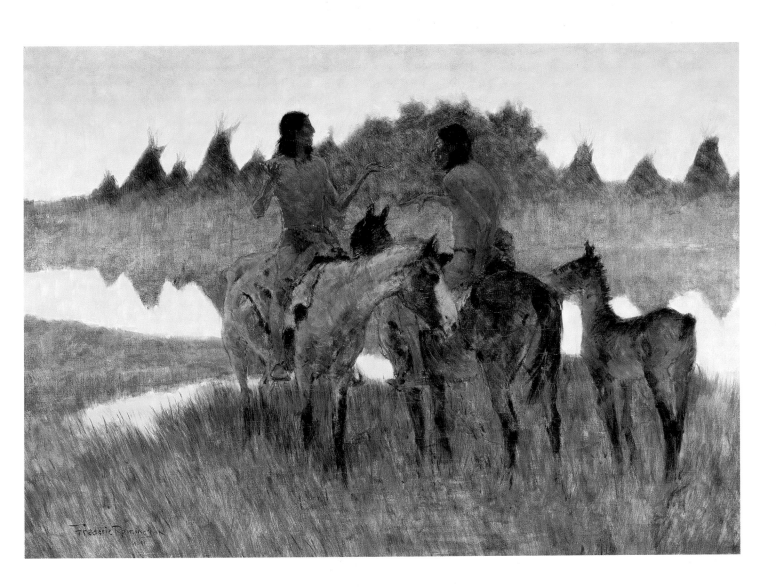

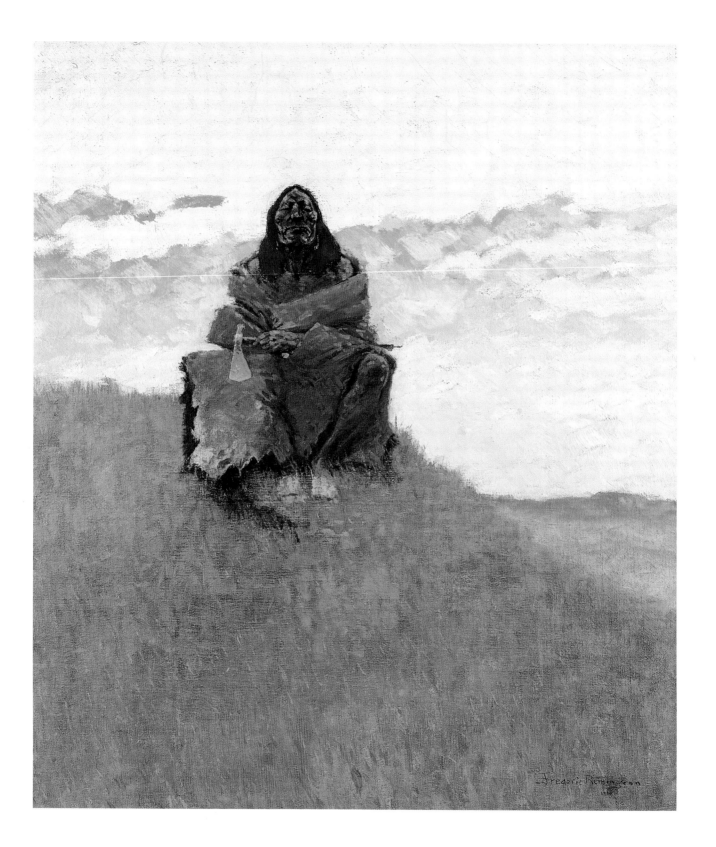

106 (above). Frederic Remington, *The Stampede*, 1909 (cast 1947–48, Roman Bronze Works, no. 5). Bronze, 21⅝ × 48⅜ × 16¼ inches. Amon Carter Museum, Fort Worth, Tex.

105 (opposite). Frederic Remington, *When His Heart Is Bad*, 1908. Oil on canvas, 30 × 27 inches. Thaw Collection, Fenimore Art Museum, Cooperstown, N.Y.

York City. "I stand for the proposition of 'subjects'—painting something worth while as against painting *nothing* well—merely paint."[22]

For both artists a blend of objectivity and subjectivity was paramount. The common elements in their work were narrative essence, imaginative force, and technical proficiency—and the determined view that the West and its people, its history, and its place in the American experience truly mattered. The cowboy in Russell's *The Slick Ear* (figure 94) is the quintessential expression of these elements, as is Remington's bronze *The Stampede* (figure 106). Russell mixed dynamics and humor, while Remington blended a similar kinetic quality with a hint of impending doom.

Russell's work, because of his proximity to the scenes he painted, was generally more sensory, more perceptual. Remington's paintings, given his physical and emotional distance from the West, tended to be more abstract, more conceptual. This may explain in part Russell's persistent reliance on figuration, on precise representation. Another part of the explanation had to do with his audience, many of whom were rural and western and, as William Kittredge, Montana's great writer on modern western life, has noted, "didn't know much about

painting but loved the idea that somebody had taken their part of the world so seriously. Wouldn't most of us find pride in the idea that a famous artist like Charlie Russell had focused a lifetime of attention on our part of creation? And that he cared enough to get everything right? That was important, getting everything right."[23]

Several of Remington's late paintings, especially his views of dusk and his nocturnes, were hauntingly lyrical. Contemplative studies such as *The Gossips* (figure 104) offered warmly inviting scenes that resonate with the rhythms of Indian life. Here silhouetted tepees establish visual rhythms that mirror the musical voice of the Indian people and in the process lift the viewer to a higher plane of consciousness. The two mounted figures interconnect in subtle parley, and the composition's circular grouping, which includes the young folk, speaks to the natural cycle of life and to continuity, endurance, and nature's melodies. Through such elements the viewer experiences a transcendence and a sense of harmonizing with nature. Remington's earlier work had viewed nature as an expression of finality, often a void, peopled with heroic figures set against long odds—even, in fact, a malevolent force.

But in his late works, such as *When His Heart Is Bad* (figure 105), he discovered euphony among the voices of man and nature. At the end of Remington's career, a critic would write, "his color is more and more inevitably related to his ideas, as if nature herself had spread his palette.... In some of his more recent work he seems to have used his medium unconsciously, as a great musician does his piano and score."[24]

Russell had long known those sounds and made them part of his art. His canon is filled with works that attest to the equilibrium of nature's forces, man included. For Russell, nature provided a vast reservoir of symbols and moral associations. In its purest form nature was a symbol of continuity. The bison in *The Buffalo Herd* (figure 24), for example, represent the several generations that have come to drink at the Missouri River.

107. Charles M. Russell, *The Range Father,* 1926.
Bronze, 5 1/8 × 14 1/2 × 5 1/2 inches.
The Saint Louis Art Museum, St. Louis, Mo.
Bequest of Arthur C. Hoskins.

STORYTELLERS WITH A BRUSH AND BRONZE

In addition to the landscape and the western light, Russell's love of nature was excited by the whole animal kingdom. He was naturally drawn to bison and horses, whose interaction he explored in countless buffalo hunt scenes. But he seemed enamored of all animals except dogs, which reminded him of the sheep industry that had driven the cattle from the range.[25] He frequented zoos and modeled and painted a wide variety of animals both domestic and wild. The *Helena (Mont.) Daily Independent* opined in 1901 that Russell would not only rival Remington as an artist of western life but would also some day "surpass the world's best animal painters."[26] Russell's depictions of bears and wolves—for example, in *The Range Father* (figure 107)—are handled with great sensitivity and skill, while Remington seems never to have taken the time to properly study them or articulate their features.

But in the depiction of horses, both Russell and Remington were consummate masters. William Savage has noted that Remington "deliberately chose dramatic artistic situations expressly to exhibit his knowledge of horse anatomy."[27] Russell, no doubt, did much the same thing. And when it came to rendering horses, no medium was more pleasing to the two artists than bronze. Both artists embarked on sculpture in midcareer, Remington in 1895. His first effort, *The Broncho Buster* (figure 8), elicited his comment that it was "a great art and satisfying to me, for my whole feeling is for form."[28] Sculpture

came naturally to him, and he thrilled at its potential to invigorate his creative life. The art critic Arthur Hoeber regarded this piece as a "breaking away" from the constraints of two-dimensional work and was amazed at the ease with which Remington made the move from canvas to bronze. It was "quite astonishing that the difficulties of technique in the modeling in clay should have been overcome so readily and with such excellent results," Hoeber observed in 1895.[29]

Although Russell probably worked in three-dimensional forms from the time of his youth, he did not turn seriously to sculpture until 1903. As with Remington, the new medium rewarded him with instant success. He found modeling "a lot easier than drawing," and to Hoeber, who critiqued Russell's work in 1911, the sculptures were actually "more convincing" than his paintings of the period.[30] In sculpture Russell could avoid the problems of color that vexed him in the early years of the new century while he explored perceptions of unequivocal physical action.

Comparing Russell's first bronze, *Smoking Up* (figure 6) with Remington's first bronze provides some useful insights. Russell's piece is reduced in scale but easily packs as much visual impact. As the Russell scholar Frederic Renner noted, Russell "was a vital person, concerned with vital subjects all his life. This vitality is in his sculpture."[31] Vibrant with life, his small, freely modeled work feels remarkably unstylized next to the larger Remington casting. *The Broncho Buster*, although only two feet high itself, has a monumental, heroic character, but when compared with Russell's piece it seems constrained by its relative formal presentation. This is not to say that Remington's work lacks vitality, for compared with the vast majority of sculpture by his contemporaries, *The Broncho Buster* is extremely dynamic. Yet the modeling is precise, the surface glassy, and the contours clean, as if to contain the mass within as much as to express the form without.

The Broncho Buster proved to be Remington's most popular bronze, and he went on to produce more statuettes of cowboys than any other subject he attempted to sculpt. Nonetheless, the sculpture that became the next most appealing to the public was a bronze figure of an Indian warrior, *Cheyenne* (figure 109). Copyrighted in 1901, this work depicts a warrior of one of his favorite Indian tribes. It also relates to his first novel, *The Way of an Indian* (1906), the story of White Otter, a Cheyenne warrior whom Remington traced through a series of heroic exploits from his glories as a young warrior and later leader of his

108 (above). Frederic Remington, *The Sergeant*, ca. 1904. Bronze, 10¼ × 5¾ × 5 inches. Diplomatic Reception Rooms, U.S. Department of State, Washington, D.C.

109 (opposite). Frederic Remington, *Cheyenne*, 1901 (Roman Bronze Works, no. 40). Bronze, 19¾ × 23½ × 9 inches. The Rockwell Museum of Western Art, Corning, N.Y.

111 (above). Frederic Remington, *Captain Dodge's Colored Troopers to the Rescue,* ca. 1890. Tempera on paper mounted on academy board, 19 1/2 × 36 11/16 inches. The Flint Institute of Arts, Flint, Mich. On loan from the Estate of Ruth Mott.

110 (opposite). Charles M. Russell, *Counting Coup,* 1907. Bronze, 12 × 16 × 14 inches. Mr. and Mrs. W. D. Weiss, Jackson, Wyo.

people, whom Remington called the Chis-Chis-Chash, to his defeat at the hands of the U.S. military.

Similarly, Russell's most vigorous early bronze, *Counting Coup* (figure 110), reflects one of his favorite themes. Like Remington, Russell selected a dramatically symbolic episode and a favorite Indian tribe, his beloved Piegan Indians, to carry the narrative. Russell's bronze evolved from a story he often told about a Piegan chief named Medicine-Whip, a quintessential natural man who survives a pitched battle with Sioux horse thieves.[32] In this story, a tribute to human valor, Medicine-Whip is the first to strike, or count coup, on the enemy in battle. Through superior horsemanship, raw courage, and tactical finesse, Medicine-Whip vanquishes his adversaries, emerging as an emblem of survival and perseverance.

Russell once wrote that Remington was, above all, "good on soldiers."[33] And although as his career progressed Remington painted and sculpted fewer and fewer images of military men carrying out their mission in the West, he never abandoned the subject. Despite the fact that in his later canvases Native Americans are glorified in

reverie, he never swerved from his basic contention: U.S. military troops had "won" the West, thus providing him with the subjects for his art. In the end Russell's lament for the passing of the old West was probably more genuine, Remington's distant and calculated.

In his depictions of cavalry in the West, Remington should be recognized for adding some vital dimensions that other artists had ignored, including Charles Schreyvogel and Russell himself. In his early works Remington celebrated the African American soldier and his role in the post–Civil War frontier. Paintings such as *Captain Dodge's Colored Troopers to the Rescue* (figure 111), painted around 1890 and *The Advance* (figure 112), painted in 1896–98, depicted black cavalrymen on active duty on the front line. In *The Advance*, a jowly white officer shields his gaze from the sun's glare, while two of the three black soldiers scan the horizon, their free hands holding Spencer rifles readied for action. In a full-length portrait entitled *The Alert* (1888), Remington singles out a black cavalryman as worthy of individual recognition, giving him a proud bearing and significance of stature. Such revealing depictions of troops of the Ninth and Tenth Cavalry counter the current thesis that the artist whitewashed the scene.[34]

Criticism of Remington for leaving African Americans out of his western paintings—erasure, as modern critics refer to it—is valid only with respect to his avoidance of literary or pictorial reference to them as cowboys. In fact, neither he nor Russell made a place for the black cowboy in their art, although some scholars have suggested that one-third of all cowboys were black. Remington simply may not have given the issue any thought. Russell personally knew some black cowboys but preferred not to include them in his circle or in his art. "I don't think any man is better than another till he proves it," he wrote on one occasion to his protégé Joe DeYong. As for black cowboys, "there's some good ones and some that can ride, [but] I wouldn't want to mix with them."[35]

Both Remington and Russell excelled in their interpretations of the cowboy. Through their paintings and bronzes of the subject they created not just an emblem of American manhood but also an icon of national identity. Remington's works tended to be more fatalistic, while Russell's brimmed with life, fun, and a healthy regard for hard work. Remington's cowboys battled nature, while Russell's seemed to find a place within it. For both, the cowboy was so central to their artistic core that the symbol they created in turn defined them as creative forces.

112. Frederic Remington, *The Advance*, 1896–98. Oil on canvas, 27 1/4 × 40 1/8 inches. Desert Caballeros Western Museum, Wickenburg, Ariz.

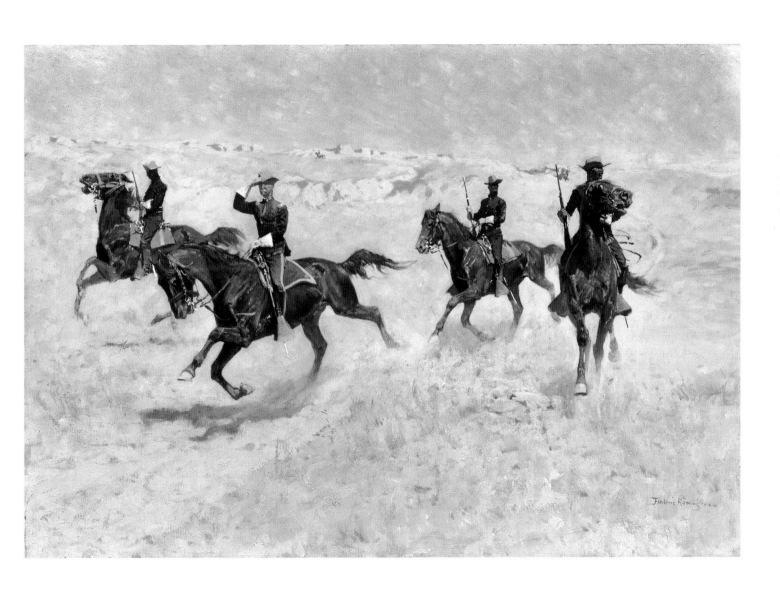

A Different Light

F rom the time of Russell's emergence on the national art scene at the beginning of the twentieth century, he was frequently compared with Remington, the more established artist. There are no known documented references of Remington's opinion of Russell or his work. However, it is known that Russell was embarrassed by such comparisons. Austin Russell, the artist's nephew, recounted one occasion in which a writer of western stories, trying to court favor with Russell, delivered a diatribe against the easterner: Remington was a newspaperman, not an artist; he could draw only one kind of horse and one kind of man; the only way to tell a Remington cowboy from a Remington Indian was that the cowboy wore a flop hat and a big yellow mustache; Remington himself got so grossly fat that he could not ride horseback but had to be hauled around in a cart like a prize pig; and he died of overeating.

Russell's *Mexican Buffalo Hunters* (figure 101) reveals his mastery of light, even in the Southwest, with which he was relatively unfamiliar. Remington also made careful studies of western light for canvases to be finished in his studio.

"You suppose it's true?" I asked when the writer had gone.

"Well he did get fat," said Charlie, "and he died comparatively young, but that, as Bill Krieghoff would say, is not a 'valid' criticism of his art."

"I'll bet," said Charlie, "that years from now when some critic compares our pictures," (for as the result of hearing it so often he had accepted the idea, at first unthought of, that his work was historically important) "what he'll notice is that Russell and Remington saw the same country, but not the same colors, and *that's* all a difference of light."[1]

Russell's discomfort with comparisons between himself and Remington became well known. He hated such assessments and felt particularly frustrated when, as they invariably did, the critiques came out in his favor. "His generous, unselfish heart rebelled against comment touching his work and that of another great artist of the out-of-doors, the late Frederick [sic] Remington," wrote an admirer in 1927. "He felt always that such talk was moonshine, and he resented anyone saying that he was 'as good' or 'better' than Remington."[2] Yet, especially after Remington's death, Russell was thrust into the New Yorker's footsteps. As much as he disliked it, the comparisons propelled him into a new and ascendant role. "Since the death of Frederic Remington," contended Arthur Hoeber, who admired them both, Russell was "almost without a competitor, among men artistically endowed, the official historian of the West that has passed."[3]

Critics generally hold that the point of greatest commonality between the two men as artists was their relative disposition toward accuracy. Robert Taft, an early historian of western art, took the classic stance in this regard, proposing that because of Russell's permanent residence in the West and his years of experience as a cowboy, "his work is frequently more exact as far as detail goes, than was that of Remington, who was primarily interested in action rather than exact detail."[4] Russell thus became in people's minds a purveyor of fact, Remington of fleeting images. In truth, however, both were concerned enough with detail to be termed visual documentarians, and both were sufficiently uncommitted to exactitude to satisfy their own romantic inclinations. They were equally intrigued with pictorial dynamics as well. The portrayal of men and horses in action is no more frequent in Remington's paintings than in Russell's. It became a hallmark of both their styles by virtue of the scenes they chose to re-create.

113. Frederic Remington, *An Indian Dream*, 1898. Oil on canvas en grisaille, 40 × 26 3/4 inches. Gilcrease Museum, Tulsa, Okla.

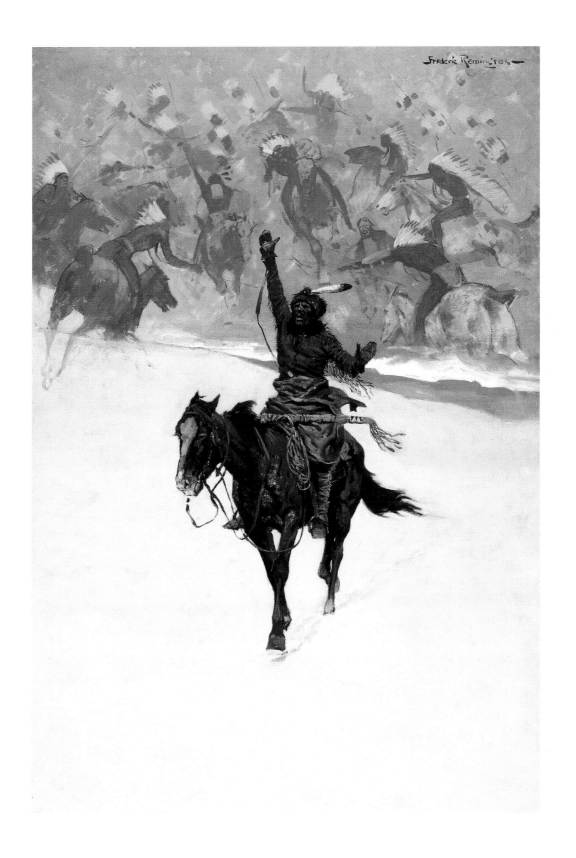

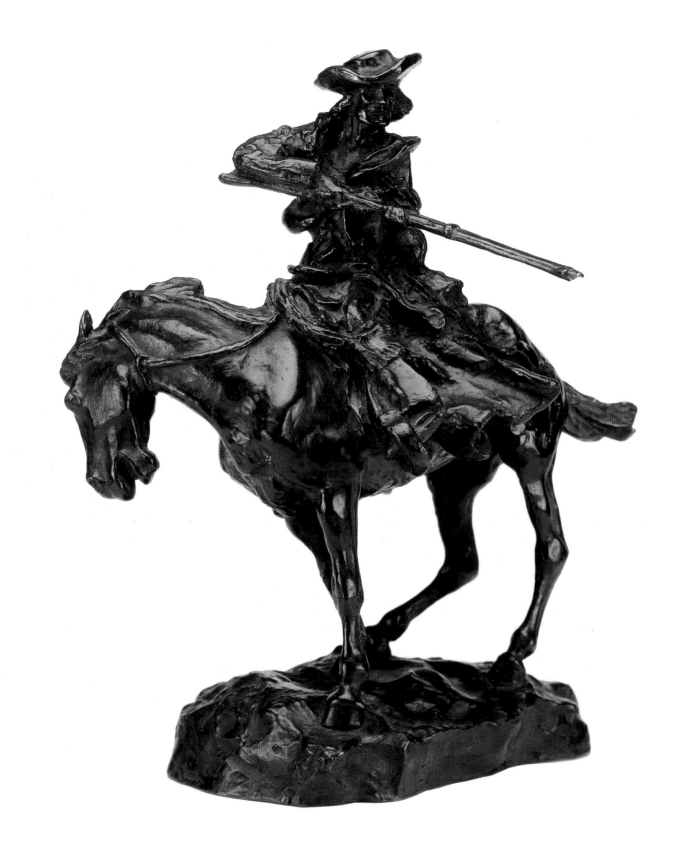

115 (above). Frederic Remington, *Mountain Man*, 1903 (cast 1912, Roman Bronze Works, no. 26). Bronze, 29 × 16 × 19 inches. Collection of Phoenix Art Museum, Phoenix, Ariz. Anonymous gift. Work exhibited in Memphis, Palm Beach, and Portland on loan from the Birmingham Museum, Birmingham, Ala.

114 (opposite). Charles M. Russell, *Jim Bridger*, ca. 1929. Bronze, 14 1/2 × 13 1/2 × 9 1/2 inches. Spencer Museum of Art, The University of Kansas, Lawrence, Kans. Anonymous gift in memory of Mr. and Mrs. W. P. Innes and Mr. and Mrs. L. E. Phillips.

This is not to say that, from a technical standpoint, there are not a host of differences between them. As in his sculpture, Russell's draftsmanship generally embodied a vitality lacking in Remington's work. Remington admitted late in life that he did not feel much at ease with pen and ink. He eventually discarded drawing almost entirely, preferring to rely primarily on his facility with a brush. Russell was unwilling to sacrifice the linear definition of his pictures, and his oils are therefore less painterly than Remington's.

With regard to composition, Remington's work shows more variation. Russell clung to a few standard compositions and strayed from these only rarely. Whether painting the buffalo hunt or the classic flight from avenging Indians, Russell used an elongated triangular composition, heavily weighted on one side by figures and counterbalanced on the other side by mountains or a brilliant sunset. *Salute of the Robe Trade* (figure 88) exemplifies this structure.

In their use of color, too, there are considerable differences between Russell and Remington. In his mature work Remington turned often to the depiction of nighttime scenes. In fact, approximately half of his works during the last five years of his career were nocturnes. His interest in the effects of moonlight was not shared by Russell, whose occasional attempts lose their romance in a rather muddy overcast. Russell concentrated his efforts on the twilight as it radiated across the broad Montana horizon, capturing the effects quite brilliantly. As artistic statements, however, his glowing backdrops became somewhat clichéd.

Russell's use of color was never as venturesome as Remington's. Although in his mature paintings Remington tended to reduce his palette to pastel hues, he achieved some stunning contrasts as well. This, together with his powerful brushwork, produced boldly impressionistic works. Russell's colors, especially after 1900, when his palette was greatly expanded, tended to be more garish than harmonious. It was primarily in his watercolors that he achieved supremacy in the interpretation of light, thereby exploring color to the fullest. In this medium Russell excelled; he was facile, subtle, and exact, often surpassing Remington.

K. Ross Toole, former director of the Montana Historical Society, has pointed out that "the real power of Russell's works does not reside in technique. It resides in the fact that he felt, to the very depths of his being, that an era was dying—and that it meant something."[5] Remington too worked on that premise. Because of Remington's singular devotion to the bygone saga of the American West, Theodore Roosevelt eulogized, "the soldier, the cowboy and rancher, the Indian, the horse and the cattle of the plains, will live in his pictures ... for all time."[6]

Together these two artists have left a pictorial record of the West unprecedented in its richness of observation, imagination, and artistry. In fact, they fashioned America's image of the vanished western frontier. Although intending only to relate visually what had gone before, they ultimately became as much creators as perpetuators of the western theme. They had been present at a fundamentally transformative time in the West: the 1880s and 1890s. They were willing, interested, and able to address artistically the changing scene that the art historian Martha Sandweiss has aptly described as one of the principal "shifts in Western history, the point at which a frontier of boundless possibilities became in the American imagination a more mundane region whose uniqueness lay in its past."[7] And as they approached that complex task, each responsive to the evolving tableau and depicting it in his own style, perspective, and technical methodologies, they did so with an independence of spirit and a conscious avoidance of canonical norms. Both had spirit and artistic energy, and both died at the peak of their powers. Today Remington and Russell are worthy claimants of a title conferred a half century ago: the most celebrated of all the artists of the West.

116. Charles M. Russell, *A New Year's Story in Tracks*, 1908. Pen and ink and watercolor, 9½ × 6½ inches. Mr. and Mrs. W. D. Weiss, Jackson, Wyo.

1908

A New Year's Story in Tracks.

"It's time for good resolutions,"
Is what the pious folks say,
"But if trails don't lie — its plain to the eye
There ain't been but one made to-day."

Frederic Remington
Fort Keough, Mt.

Notes

"THE MOST CELEBRATED ARTISTS OF THE WEST"

1. "Prefers Ulm to New York as a Place of Residence," *Great Falls (Mont.) Daily Tribune*, 16 February 1904, p. 8.

2. Russell to H. Percy Raban, 3 May 1907, Buffalo Bill Historical Center, Cody, Wyo.

3. "Prefers Ulm to New York," p. 8.

4. "Russell's Work at St. Louis Fair," *Great Falls (Mont.) Daily Tribune*, 9 October 1903, p. 8.

5. "Prefers Ulm to New York," p. 8.

6. William A. Coffin, "American Illustration of To-day," *Scribner's Magazine*, vol. 11 (March 1892): 348.

7. See James D. Horan, *The Life and Art of Charles Schreyvogel* (New York: Crown, 1969), 34–40.

8. "Paintings by Remington; Grim Tragedies of the Plains Told in Strong Colors," *New York Times*, 15 March 1904, p. 8, and "Custer's Demand," *New York Herald*, 19 April 1903, p. 9.

9. Lorado Taft, *The History of American Sculpture* (New York: Macmillan, 1903), 438. See also "Mr. Borglum's Broncos and Bronco-Busters," *Harper's Weekly* 47, no. 2421 (16 May 1903): 790.

10. Robert Taft, *Artists and Illustrators of the Old West 1850–1900* (New York: Charles Scribner's Sons, 1953), 176.

11. For a full account, see Brian W. Dippie, *Catlin and His Contemporaries: The Politics of Patronage* (Lincoln: University of Nebraska Press, 1990), and Nancy K. Anderson and Linda S. Ferber, *Albert Bierstadt: Art and Enterprise* (New York: Hudson Hills Press, 1990), 40–53.

12. Quoted in W. Vernon Kinietz, *John Mix Stanley and His Indian Paintings* (Ann Arbor: University of Michigan Press, 1942), 17.

13. Part of this book is based on a catalogue text written in 1974 for the exhibition *Remington and Russell*, organized by the Art Museum of South Texas, Corpus Christi. Certain insights have changed since then, but the author is grateful to the museum and its director, William G. Otton, for allowing the use of appropriate segments of that original essay in this volume.

AN UNWITTING RIVALRY

1. Edwin Wildman, "Frederic Remington, the Man," *Outing* 4 (March 1903): 712–16.

2. *Ibid.*

3. *Ibid.*

4. Frederic Remington, *John Ermine of the Yellowstone* (New York: Macmillan, 1902). For the variant interpretations of this work, see Fred Erisman, *Frederic Remington* (Boise, Idaho: Boise State University, 1975), 28, and John Seelye, "The Writer," in Michael Shapiro et al., *Frederic Remington: The Masterworks* (New York: Harry N. Abrams, 1988), 254.

5. Wildman, "Frederic Remington, the Man," 715–16.

6. Sumner W. Matteson, "Charles M. Russell, the Cowboy Artist," *Leslie's Weekly* 48, no. 2530 (3 March 1904): 204.

7. *Ibid.*

8. *Ibid.*

9. "Striking Work of Russell, Montana's Cowboy Artist," *Denver Republican*, 23 August 1903, p. 15.

10. *Ibid.*

11. See Brian W. Dippie, *Charles M. Russell: Word Painter* (New York: Harry N. Abrams, 1993), 65.

12. "Cowboy Artist, St. Louis' Lion," quoted from the *St. Louis Post-Dispatch* in *Helena (Mont.) Daily Independent*, 13 May 1901, p. 5.

13. "The Cowboy Artist," *Denver Times*, 13 July 1902, p. 10.

14. Quoted in *Contributions to the Historical Society of Montana . . .* , vol. 5 (1904): 103.

15. "Charles Russell, Cowboy Artist," *Butte (Mont.) Miner*, 11 October 1903, p. 5.

16. Erwin E. Smith, "Artists and Western Life," *Great Falls (Mont.) Daily Tribune*, 21 January 1904, p. 8.

17. George Pattullo, "From Bronco Buster to Boston Art Student," *Boston Herald*, 12 January 1908, magazine section, p. 1.

18. Smith repeated and expanded on his original critique in an article he concocted with Harry Peyton Steger, "Photographing the Cowboy as He Disappears," *The World's Work* 17 (January 1909), especially pp. 11113 and 11123.

19. Philip L. Hale, "Art," *Boston Herald,* 9 January 1909.

20. Remington diary, 11–14 January 1909, Frederic Remington Art Museum, Ogdensburg, N.Y.

21. Giles Edgerton, "What Does the National Academy of Design Stand For? Has It at Present a Value to the American Art Public?" *The Craftsman* 15, no. 5 (February 1909): 522.

22. For a full discussion of this exchange, see Byron Price, *Imagining the Open Range: Erwin E. Smith, Cowboy Photographer* (Fort Worth, Tex.: Amon Carter Museum, 1998), 45–48.

23. Edward B. Clark, "Roosevelt on Nature Fakers," *Everybody's Magazine* 17 (September 1907): 423–43. See also Ralph H. Lutts, *The Nature Fakers: Wildlife, Scinece, and Sentiment* (Golden, Colo.: Fulcrum, 1990), 101–38.

24. Hough to Smith, 23 July 1907, quoted in Price, 46.

25. Emerson Hough, *The Story of the Cowboy* (New York: D. Appleton, 1900). The other illustrator, William L. Walls of California, adopted most of his images directly from photographs. For example, *Cutting Out* (opposite p. 46) derives from a Charles Kirkland photograph of the same title from about 1885.

26. Remington diary, 6 April 1908, Frederic Remington Art Museum, Ogdensburg, N.Y.

27. Hough, "Wild West Faking," *Collier's* 42, no. 13 (19 December 1908): 18.

This notion persists today in writings about the two artists. Russell's most recent biographer, John Taliaferro, credits Remington as having established "authenticity ... as a sine qua non" in western American art but as being a "counterfeit himself." See Taliaferro, *Charles M. Russell: The Life and Legend of America's Cowboy Artist* (Boston: Little, Brown, 1996), 83.

28. Remington diary, 19 and 22 December 1908 and final 1908 entry (undated), which lists the paintings he burned, Frederic Remington Art Museum, Ogdensburg, N.Y.

29. Philip Ashton Rollins, *The Cowboy: An Unconventional History of Civilization on the Old-Time Cattle Range* (New York: Charles Scribner's Sons, 1936), xi. In 1924 Russell came to Hough's defense on matters of accuracy that were being questioned by critics of his book *North of 36;* see Dippie, *Charles M. Russell: Word Painter*, 342–43.

30. See Peter H. Hassrick, *Frederic Remington: Paintings, Drawings, and Sculptures in the Amon Carter Museum and the Sid W. Richardson Foundation Collections* (New York: Harry N. Abrams, 1973), 28–30.

31. David J. Nordloh, *Emerson Hough* (Boston: Twayne Publishers, 1981), 93–94.

32. Steger, "Photographing the Cowboy as He Disappears," 11123.

33. See, for example, Russell, "A Few Words about Myself," in *Trails Plowed Under* (Garden City, N.Y.: Doubleday, 1927), xx, and Frank Bird Linderman, *Recollections of Charley Russell* (Norman: University of Oklahoma Press, 1963), 87.

34. "Russell and Remington," *Great Falls (Mont.) Daily Tribune*, 6 January 1910, p.6.

35. Gutzon Borglum, "A Westerner's Point of View," *New York Tribune,* 5 December 1926, p. 107.

PORTRAITS OF THE ARTISTS

1. See Austin Russell, *Charles M. Russell: Cowboy Artist* (New York: Twayne Publishers, 1957), and John Taliaferro, *Charles M. Russell: The Life and Legend of America's Cowboy Artist* (Boston: Little, Brown, 1996). For Remington, see Peggy Samuels and Harold Samuels, *Frederic Remington: A Biography* (New York: Doubleday, 1982).

2. Taliaferro, *Charles M. Russell: The Life and Legend of America's Cowboy Artist*, 17–20, and Atwood Manley and Margaret Manley Mangum, *Frederic Remington and the North Country* (New York: E. P. Dutton, 1988), 42.

3. *St. Lawrence Plaindealer*, 10 August 1881.

4. Orison Swett Marden, *Little Visits with Great Americans* (New York: The Success Company, 1905), 328.

5. Frederic Remington, "A Few Words from Mrs. Remington," *Collier's* 34, no. 25 (18 March 1905): 16.

6. "Striking Work of Russell, Montana's Cowboy Artist," *Denver Republican*, 23 August 1903, p. 15.

7. Josiah Gregg, *Commerce of the Prairies*, vol. 2 (New York: H. G. Langley, 1844), 156–57.

8. Wallace Stegner, "Who Are the Westerners," *American Heritage* 38 (December 1987): 35.

9. See Henry T. Tuckerman, *Book of the Artists* (1867; reprint, New York: James F. Carr, 1966), 389, and Peter Hassrick, *The Way West: Art of Frontier America* (New York: Harry N. Abrams, 1977), 16.

10. Barbara Novak, *Nature and Culture: American Landscape and Painting, 1825–1875* (New York: Oxford University Press, 1980), 137.

11. Alpheus S. Cody, "Rise of Remington," *New York Herald*, 14 January 1894, p. 13. For reference to Remington as a cowboy in 1889, see Cromwell Childe, "A Study of the Horse," *Denver Republican*, 1890, and Hassrick, "Frederic Remington the Painter: A Historigraphical Sketch," in Hassrick and Melissa T. Webster, *Frederic Remington: A Catalogue Raisonné of Paintings, Watercolors and Drawings* (Cody, Wyo.: Buffalo Bill Historical Center, 1996), vol. 1, 42–43. For discussion of Remington's association with Wister, see Ben Merchant Vorpahl, *My Dear Wister* (Palo Alto, Calif.: American West, 1973), 33–76.

12. "A Diamond in the Rough," *Helena (Mont.) Daily Herald*, 24 May 1887.

13. *Fergus County (Mont.) Argus*, 23 May 1889, p. 2.

14. See Charles M. Russell, "A Few Words about Myself," in *Trails Plowed Under* (Garden City, N.Y.: Doubleday, 1927), xix.

15. See Ray A. Billington, *America's Frontier Culture* (College Station, Tex.: Texas A&M University Press, 1977), 14.

16. These ideas are developed more fully in several sources, the most readable of which are Joshua C. Taylor, *America as Art* (New York: Harper and Row, 1976), 135–82 (see particularly John G. Cawelti, "The Frontier and the Native American"), and Dawn Glanz, *How the West Was Drawn: American Art and the Settling of the Frontier* (Ann Arbor: UMI Research Press, 1982).

17. "Joe DeYong Pays Tribute to Charles Russell as First and Best Artist of Kind," unidentified newspaper clipping, 25 August 1930, DeYong Papers, C. M. Russell Museum, Great Falls, Mont.

18. Dippie, *Looking at Russell* (Fort Worth, Tex.: Amon Carter Museum, 1987), and "Two Artists from St. Louis: The Wimar-Russell Connection," in Janice K. Broderick, ed., *Charles M. Russell: American Artist* (St. Louis: Jefferson National Expansion Historical Association, 1982), 20–34.

19. See *Catalogue of Paintings on Permanent Exhibition* (St. Louis: Museum of Fine Arts, 1901). For a list of articles on Wimar from St. Louis newspapers of the period, see Rick Stewart et al., *Carl Wimar: Chronicle of the Missouri River Frontier* (Fort Worth, Tex.: Amon Carter Museum, 1858), 242–45.

20. Russell's notes to DeYong, Joe DeYong Papers, National Cowboy Hall of Fame Library, Oklahoma City, Okla.. See also Austin Russell, *Charles M. Russell: Cowboy Artist*, 40–41.

21. See Hassrick, "Remington the Painter," in *Frederic Remington: The Masterworks*, eds. Michael Shapiro and Peter Hassrick (New York: Harry N. Abrams, 1988), 96–104.

22. Quoted in Peggy Samuels and Harold Samuels, *Frederic Remington: A Biography* (New York: Doubleday, 1982), 124.

23. See Brian W. Dippie, "Frederic Remington's West: Where History Meets Myth," in Chris Bruce et al., *Myth of the West* (New York: Rizzoli, 1990), 114.

24. Dippie, *Looking at Russell*, 11.

25. See Charles M. Russell, *Studies of Western Life* (Cascade, Mont.: Albertype Company, 1890), 23.

26. Theodore Roosevelt, *Theodore Roosevelt's Ranch Life and the Hunting Trail* (New York: Century, 1888).

27. For a description of the Russell series, see Frederic G. Renner, *Charles M. Russell (1846–1926): Paintings, Drawings, and Sculpture in the Amon Carter Museum* (Austin: University of Texas Press, 1966), 73–84, and William W. Cheely and H. Percy Raban, *Back-Trailing on the Old Frontier* (Denver: John Osterberg, 1990).

28. Quoted in Dippie, *Looking at Russell*, 120. Joe DeYong once wrote that this credit to Parrish was "baseless exaggeration" and nothing more than a "rumor." Joe DeYong Papers, C. M. Russell Museum, Great Falls, Mont.

29. *Harper's Weekly*, 16 October 1886, p. 1024.

30. *Harper's Weekly*, 21 December 1889, pp. 1016–17.

31. Dippie, "Two Artists from St. Louis," 28–30.

32. Mathew Baigell, *Albert Bierstadt* (New York: Watson-Guptill, 1981), 64. Nancy K. Anderson and Linda S. Ferber, *Albert Bierstadt: Art and Enterprise* (New York: Hudson Hills Press, 1990), 100–103, take a somewhat more balanced viewpoint. Hassrick also discusses these works from this perspective in *Charles M. Russell* (New York: Harry N. Abrams, 1989), 55–58.

33. Russell, *Studies of Western Life*, 14. See also Russell's 1892 oil painting

Shooting the Buffalo (Amon Carter Museum, Fort Worth, Tex.), for additional evidence that he believed that Anglo-Europeans as well as native peoples had a hand in the bison's demise.

34. See Manet's *Bullfight* (1864–65), Frick Collection, New York. For discussion of this work, see T. A. Aronberg, *Manet: A Retrospective* (New York: Hugh Lauter Levin Associates, 1988).

35. Roosevelt, *Theodore Roosevelt's Ranch Life and the Hunting Trail*, 104.

36. George Schriever, "Russell [and] Remington," *Southwest Art* 6, no. 11 (May 1977): 42.

37. Quoted in Barnaby Conrad III, "C. M. Russell and the Buckskin Paradise of the West," *Horizon* 22, no. 5 (May 1979): 42. See also "Cowboy Artist, St. Louis Lion," *Helena (Mont.) Daily Independent*, 13 May 1901, p. 5, and "The Cowboy Artist," *Denver Times*, 13 July 1902.

38. Charles M. Russell, "A Few Words about Myself," xix.

39. "Sale of Russell Painting for Ten Thousand Dollars Sets New Mark for Montana Artist," *Inserts* [Montana News Association] 4 (25 May 1921), p. 264.

40. Russell often used the phrase *regular men* in his writings and letters, e.g., Russell to Philip Cole, September 26, 1926, Gilcrease Museum Collection, Tulsa, Okla. Remington used the phrase *men with the bark on* in letters and for the title of his 1900 book. According to one of his most serious early students, Helen Card, it expressed "more of Remington's subject matter in pictures, writing and sculpture than any phrase he ever used…." Helen L. Card, *The Collector's Remington* (Woonsocket, R.I.: Helen Card, 1946), 7.

41. "Sale of Russell Painting," p. 264.

42. Royal Cortissoz, "Frederic Remington: A Painter of American Life," *Scribner's Magazine* 47, no. 2 (February 1910): 192.

43. Harold McCracken, *Frederic Remington: Artist of the Old West* (Philadelphia: J. B. Lippincott, 1947), 112.

44. William H. Goetzmann and William N. Goetzmann, *The West of the Imagination* (New York: W. W. Norton, 1986), 239.

45. Patricia Nelson Limerick, "The Rendezvous Model of Western History," in Stewart L. Udall et al., *Beyond the Mythic West* (Salt Lake City: Peregrine Smith, 1990), 35–43.

46. *Ibid.*, 41.

47. Quoted in Allen P. Splete and Marilyn D. Splete, *Frederic Remington: Selected Letters* (New York: Abbeville Press, 1988), 261.

48. This painting has also been interpreted as a prurient work in which the cowboy is bargaining for the young woman's favors. See Taliaferro, *Charles M. Russell: The Life and Legend of America's Cowboy Artist*, 79.

49. Washington Irving, *A Tour of the Prairies* (1835; reprint, Norman: University of Oklahoma Press, 1956).

50. Frederic Remington, "Artist Wanderings among the Cheyennes," *The Century Magazine* 38, no. 4 (August 1889): 541.

51. Robert Hine, *The American West: An Interpretive History* (Boston: Little, Brown, 1973), 299.

52. See John C. Ewers, "Charlie Russell's Indians," *Montana* 37 (Summer 1987): 36–53.

COWBOY ILLUSTRATORS, COWBOY ARTISTS

1. John C. Ewers, "Charlie Russell's Indians," *Montana* 37 (Summer 1987): 36–53.

2. Lonn Taylor and Ingrid Maar, *The American Cowboy* (Washington, D.C.: Library of Congress, 1983), 70.

3. Baylis John Fletcher, *Up the Trail in '79* (Norman: University of Oklahoma Press, 1967), 62. See also Peter Hassrick, "The Wyoming Cowboy's Evolving Image," *Wyoming Annals* 65, no. 4 (Winter 1993–94): 8–19; the author is grateful to the *Wyoming Annals* editors for permission to extract from this article for this chapter.

4. "The Cow-Boys of the Western Plains and Their Horses," *Cheyenne (Wyo.) Daily Leader*, 3 October 1882, p. 4.

5. Robert Strahorn, *Hand-Book of Wyoming* (Cheyenne, Wyo.: Knight and Leonard, 1877), 105.

6. Much has been written about Remington's reliance on Huffman's photographs. See especially Estelle Jussim, *Frederic Remington, the Camera, and the Old West* (Fort Worth, Tex.: Amon Carter Museum, 1983), 50–58.

7. Frederic Remington, "Life in the Cattle Country," *Collier's* 20 (26 August 1899): 12–13.

8. See Charles M. Russell, *Trails Plowed Under* (Garden City, N.Y.: Doubleday, 1926), 157–60 and 163–64.

9. Owen Wister, "The Evolution of the Cow-Puncher, *Harper's Monthly* 91, no. 544 (September 1895): 608–15.

10. Taylor and Maar, *The American Cowboy*, 96.

11. Russell to Robert Stuart, 16 January 1907, Amon Carter Museum, Fort Worth, Tex. However, Andy Adams, "Western Interpreters," *Southwest Review* 10 (October 1924): 73–74, quotes Russell as later feeling ill at ease with the new scene: "I know my Montana. The pay-dirt hasn't been entirely worked out in the mesas and coulees of this upper country. Why, to get

Mexico's colors accurately, I would have to live there twenty-five years. Excuse me boys, but I'm too old to take on more territory."

12. Gutzon Borglum, "A Westerner's Point of View," *New York Tribune,* 5 December 1926, p. 107.

13. Royal Cortissoz, "Frederic Remington: A Painter of American Life," *Scribner's Monthly* 47, no. 2 (February 1910): 195. See a similar modern assessment in Nancy K. Anderson, "'Curious Historical Artistic Data': Art History and Western American Art," in Jules David Prown et al., eds., *Discovered Lands, Invented Pasts: Transforming Visions of the American West* (New Haven: Yale University Press, 1992), 22.

14. Quoted in Allen P. Splete and Marilyn D. Splete, eds., *Frederic Remington: Selected Letters* (New York: Abbeville Press, 1988): 358.

15. Remington to John Howard, 27 January 1909, St. Lawrence University Library, Canton, N.Y.

16. Quoted in Donald J. Hagerty, *Desert Dreams: The Art and Life of Maynard Dixon* (Layton, Utah: Gibbs Smith, 1993), 54.

17. Joe DeYong Papers, C. M. Russell Museum, Great Falls, Mont.

18. *Ibid.*

19. "Charles Russell and His Work," *Great Falls (Mont.) Daily Tribune,* 28 July 1901, p. 1.

20. Taylor, *The American Cowboy,* 104.

21. Quoted in Peter H. Hassrick, *Charles M. Russell* (New York: Harry N. Abrams, 1989), 110. Many did not agree with Nancy. Maynard Dixon, for example, claimed in 1908 that Russell was strictly interested in "natural fact and historical accuracy. For Russell, imagination, interpretation and recreation of the subject matter—to him were non-sense." See Hagerty, *Desert Dreams,* 54.

22. Quoted in Splete and Splete, *Frederic Remington: Selected Letters,* 435.

23. William Kittredge, *Hole in the Sky* (New York: Alfred A. Knopf, 1992), 59.

24. "Music: Drama: Art: Reviews," *The Craftsman* 15, no. 4 (January 1909): 502

25. Austin Russell, *Charles M. Russell: Cowboy Artist* (New York: Twayne Publishers, 1957), 125.

26. "Cowboy Artist," *Helena (Mont.) Daily Independent* (1901), p. 5.

27. William W. Savage Jr., *The Cowboy Hero: His Image in American History and Culture* (Norman: University of Oklahoma Press, 1979), 40.

28. William A. Coffin, "Remington's Broncho Buster," *The Century Magazine* 52, no. 2 (June 1896): 319.

29. Arthur Hoeber, "From Ink to Clay," *Harper's Weekly* 39 (19 October 1895): 993.

30. For this Russell quote, see Ginger Renner, *A Limitless Sky: The Works of Charles M. Russell* (Flagstaff, Ariz.: Northland Press, 1986), 109. See also Arthur Hoeber, "The Painter of the West That Has Passed," *The World's Work* 22, no. 3 (July 1911): 14631.

31. Frederic G. Renner. *Charles M. Russell (1864–1926): Paintings, Drawings and Sculpture in the Amon Carter Museum* (New York: Abradale, Harry N. Abrams, 1986), 109.

32. Charles M. Russell, "The War Scars of Medicine-Whip," in *Trails Plowed Under* (Garden City, N.Y.: Doubleday, 1927), 177–86. For an explanation of the connection between the story and the bronze, see Rick Stewart, *Charles M. Russell, Sculptor* (New York: Harry N. Abrams, 1994), 147–51.

33. Joe DeYong Papers, C. M. Russell Museum, Great Falls, Mont.

34. See Brian W. Dippie, "Frederic Remington's West: Where History Meets Myth," in Chris Bruce et al., *Myth of the West* (New York: Rizzoli, 1990), 116.

35. Joe DeYong Papers, National Cowboy Hall of Fame, Oklahoma City, Okla.

A DIFFERENT LIGHT

1. See Austin Russell, *Charles M. Russell: Cowboy Artist* (New York: Twayne Publishers, 1957), 202–3.

2. Del Anderson, quoted in "Twenty-Four Russell Paintings Composed National Art Exhibit Recently Held in Santa Barbara," *Great Falls (Mont.) Tribune,* 23 January 1927, p. 3.

3. Arthur Hoeber, "The Painter of the West That Has Passed," *The World's Work* 22, no. 3 (July 1911): 14635. There were many similar comparisons at that time. A biting assessment with a regionally jingoistic slant was "Remington and Russell," *Great Falls (Mont.) Daily Tribune,* 6 January 1910, p. 6.

4. Robert Taft, *Artists and Illustrators of the Old West 1850–1900* (New York: Charles Scribner's Sons, 1953), 198.

5. K. Ross Toole, "Charles M. Russell," *Congressional Record* 104, no. 28 (February 24, 1958).

6. Theodore Roosevelt, "An Appreciation of the Art of Frederic Remington," *Pearson's Magazine* 18 (October 1907): 396.

7. Martha A. Sandweiss, "Views and Reviews: Western Art and Western History," in William Cronan et al., *Under an Open Sky: Rethinking America's Western Past* (New York: W. W. Norton, 1992), 186.

Further Reading

Adams, Ramon F., and Homer E. Britzman. *Charles M. Russell: The Cowboy Artist*. Pasadena, Calif.: Trail's End Publishing, 1948.

Dippie, Brian W. *Looking at Russell*. Fort Worth, Tex.: Amon Carter Museum, 1987.

————. *"Paper Talk": Charlie Russell's American West*. New York: Harry N. Abrams, 1979.

————. *Remington and Russell: The Sid Richardson Collection*. Austin, Tex.: University of Texas Press, 1982.

Goetzmann, William H., and Goetzmann, William N. *The West of the Imagination*. New York: W. W. Norton, 1986.

Greenbaum, Michael D. *Icons of the West: Frederic Remington's Sculpture*. Ogdensburg, N.Y.: Frederic Remington Art Museum, 1996.

Hassrick, Peter H. *Charles M. Russell*. New York: Harry N. Abrams, 1989.

————. *Frederic Remington: The Late Works*. Exhibition catalogue. Denver.: Denver Art Museum, 1981.

Jussim, Estelle. *Frederic Remington, The Camera, and the Old West*. Fort Worth, Tex.: Amon Carter Museum, 1983.

Renner, Frederic G. *Charles M. Russell (1864–1926): Paintings, Drawings and Sculpture in the Amon Carter Museum*. Austin: University of Texas Press, 1966.

Renner, Ginger K. *A Limitless Sky: The Work of Charles M. Russell in the Collection of the Rockwell Museum*. Flagstaff, Ariz.: Northland Press, 1986.

Russell, Austin. *Charles M. Russell: Cowboy Artist*. New York: Twayne Publishers, 1957.

Samuels, Peggy, and Harold Samuels. *Frederic Remington: A Biography*. New York: Doubleday, 1982.

Shapiro, Michael Edward. *Cast and Recast: The Sculpture of Frederic Remington*. Exhibition catalogue. Washington, D.C.: National Museum of American Art, 1981.

Shapiro, Michael Edward, and Peter H. Hassrick, eds., with essays by David G. McCollough, Doreen Bolger Burke, and John Seelye. *Frederic Remington: The Masterworks*. New York: Harry N. Abrams, 1988.

Stewart, Rick. *Charles M. Russell: Sculptor*. New York: Harry N. Abrams, 1994.

Taft, Robert. *Artists and Illustrations of the Old West 1850–1900*. New York: Charles Scribner's Sons, 1953.

Taliaferro, John. *Charles M. Russell: The Life and Legend of America's Cowboy Artist*. Boston: Little, Brown, 1996.

Vorpahl, Ben Merchant, ed. *My Dear Wister: The Frederic Remington–Owen Wister Letters*. Palo Alto, Calif.: American West, 1972.

White, G. Edward. *The Eastern Establishment and the Western Experience: The West of Frederic Remington, Theodore Roosevelt and Owen Wister*. New Haven, Conn.: Yale University Press, 1968.

Index of Artworks

A NOTE ON THE TYPOGRAPHY

The text of this book was typeset in Meyer Two, originally produced in 1926 by Linotype for the Hollywood mogul Louis B. Mayer and revived in 1994 by David Berlow for the Font Bureau. The display typeface is Bernhard Bold Condensed, created in 1912 by the German type and poster designer Lucian Bernhard and reissued by Monotype in 1991.

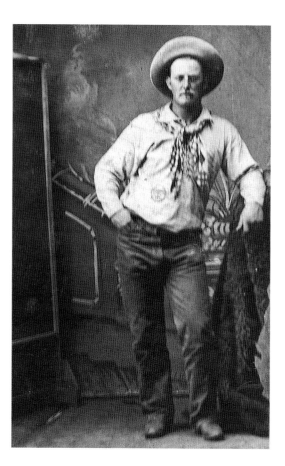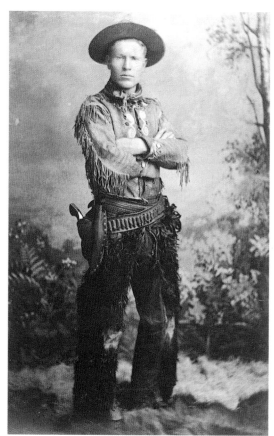